Go with the Flow Painting

Step-by-Step Techniques for Spontaneous Effects in Watercolor

Ohn Mar Win

QUARRY

Inspiring | Educating | Creating | Entertaining

Brimming with creative inspiration, how-to projects, and useful information to enrich your everyday life, quarto.com is a favorite destination for those pursuing their interests and passions.

First Published in 2023 by Quarry Books, an imprint of The Quarto Group,
100 Cummings Center, Suite 265-D, Beverly, MA 01915, USA.
T (978) 282-9590 F (978) 283-2742 Quarto.com

Quarry Books titles are also available at discount for retail, wholesale, promotional, and bulk purchase. For details, contact the Special Sales Manager by email at specialsales@quarto.com or by mail at The Quarto Group, Attn: Special Sales Manager, 100 Cummings Center, Suite 265-D, Beverly, MA 01915, USA.

10 9 8 7 6 5 4 3 2 1

ISBN: 978-0-7603-7772-7

Digital edition published in 2023
eISBN: 978-0-7603-7773-4

Library of Congress Control Number: 2022027742

Design: Amelia LeBarron
Photography: Nathalie Aubry-Stacey

Printed in USA

To my children, Zarni and Marla:
Thank you for loving, encouraging,
and inspiring me.

And to you, my creative friends:
I'm honored to be
a part of your artistic journey.

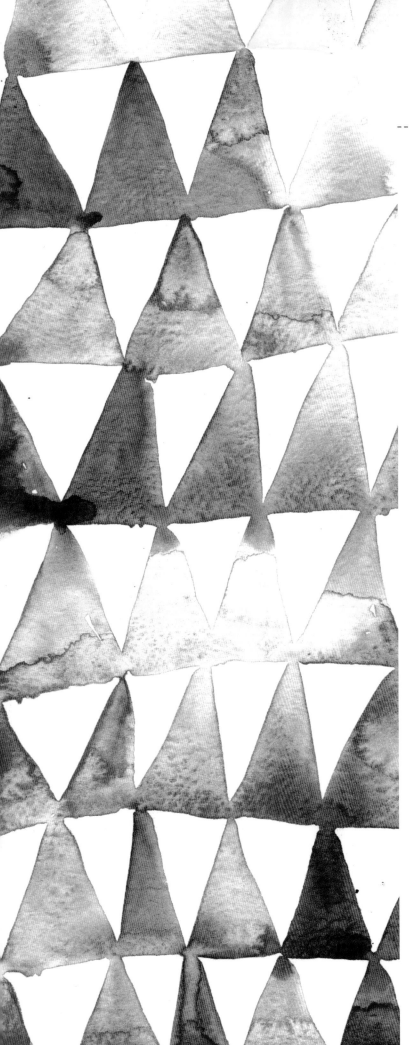

Contents

3
Warm-Up Techniques + Exercises

4
Food + Drink

5
Animals

6
Travel

7
Florals

Introduction

One of the many joys of watercolor, for me, is how expressive it can be. I simply adore watching the flow of pigments and delight in the magical textures created as the watercolor dries. Often, I deliberately encourage these effects in my sketchbooks, as I appreciate how wonderfully unique this medium is. Embracing all the happy accidents and the sometimes unexpected outcomes is like playtime for me.

My version of loose watercolor came about after several years of keeping sketchbooks. It was born as a result of needing to fit in daily art practice, among the food illustration side of my business. What evolved was a simple, fun, and fast approach, but with maximum impact. My sketchbooks were filled with vibrant fruit and florals with inky details. This combination appeals to my personal taste and capabilities, as it allows me to have a balance between my carefree side and the need for some details.

As I share so much of my art as a teacher and on social media, what I hear most often from followers and students is how my watercolors look effortless and unforced. Often they'll add, "I really want to loosen up," or, "I'd love to be able to paint more freely." It seems many artists struggle to achieve this fresh and free-flowing way of working and somehow get stuck with fiddly details and a timid approach.

The good news is there are many elements of a loose technique that can be taught. The key word is *simplification*. The more you simplify what you do, the more it frees your mind to concentrate on staying in the present and letting go of your expectations of perfection. Loose painting is about capturing an impression or essence of a scene or subject matter, rather than painting an overly realistic representation.

Big brushes and vibrant colors can take center stage in this approach, along with bolder contrast and later descriptive, inky lines. All the projects in the book are designed to be accessible to both beginners and those more experienced with watercolor, with simple pieces easing you into more complex projects with the added ink details. The demonstrations are a gentle guide to my approach that support unique and intuitive ways of working to produce enchanting, free-flowing watercolors.

1

Art Supplies

It can be overwhelming to see a huge array of art supplies, but in reality, you only need a few basics to get started with watercolor painting. You don't need thirty colors or fourteen brushes to get started. I do recommend you buy the best you can afford and choose quality over quantity. So, it's worth investing in at least student-grade materials instead of a lot of cheap tools that won't last. It's more important that you practice with watercolors and stay consistent to gain confidence.

Watercolor Paints

Watercolor paint is most commonly available in pans and tubes, but it can also be found in concentrated liquid. I think it's really personal preference which you like using.

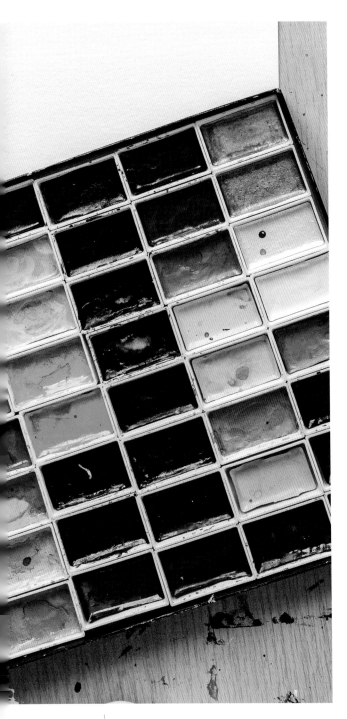

WATERCOLOR PANS

I mainly use pans, but I also have quite a lot of tubes. Watercolor pans are convenient and portable. Pans are small square "cakes" of pigment, which are put in small plastic or metal boxes to keep the paint pans together. The lid of the box that holds the paint pans usually also acts as the built-in palette for mixing, which is useful.

Pan sets come in predetermined colors, but you can also swap colors out to introduce a new color or replace any you run out of.

WATERCOLOR TUBES

Tubes of watercolor are soft and easier to mix with water. However, you need a separate palette to squeeze the paint onto, and then you must remember to put the lid on properly afterward to prevent the paint from drying out.

When you start looking at watercolors to buy you will notice a huge variation in price. I would avoid cheap children's paint and go for good-quality professional brands. Brands to look for include Winsor & Newton, Schmincke, and Daniel Smith. Try different watercolors made by different manufacturers to see what you prefer.

Watercolors come in both student- and professional-grade quality. When you are first learning I definitely recommend starting with a student set. Paints in a student set will contain more binder and less pigment, so you may have to work your brush across the dry paint several times before picking up sufficient amounts of pigment. All good-quality student-grade sets will be perfectly adequate for learning to paint with

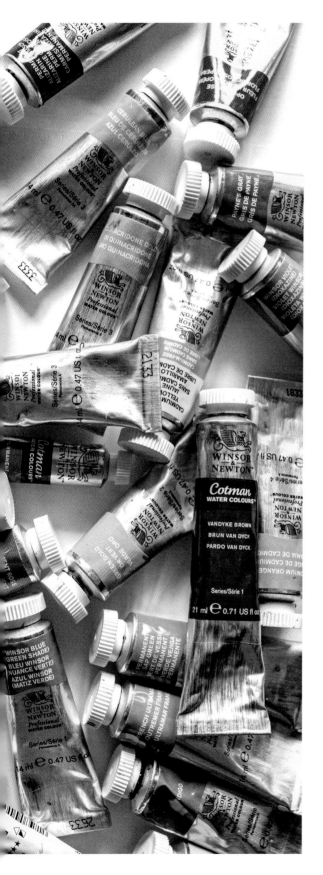

watercolors; later, consider investing in professional-quality paint sets. These are more highly pigmented, which means you will be able to pick up more color from swiping your wet brush across the pan compared with a student set. It's quite tricky to see the difference between a picture painted with artist-quality paints and one painted with student-quality paints.

Although there is a huge range of colors available, I wouldn't recommend buying a set with more than twenty colors when you start out. Often when people first start painting with watercolor, they only use the color straight out of the box, but by mixing your own colors you're learning to create something more unique. Most sets of watercolors have roughly the same range of colors, which are designed to allow the greatest variety of mixing possibilities. Paint sets often contain pans of six primary colors: a warm set and a cool set. You have two reds, two blues, and two yellows; they also contain three earth colors, usually yellow ochre, burnt sienna, and burnt umber, as well as a warm and cool green and black and white.

Brushes

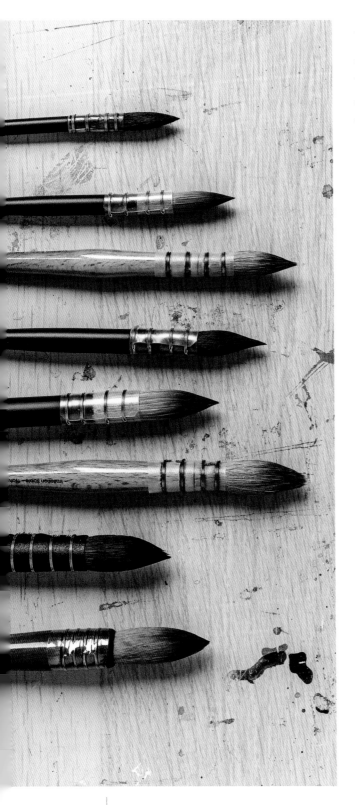

The shape of the brush often determines what kind of stroke a brush will make. During my years of painting I've gone through several phases, from water brushes (a small brush with a built-in reservoir that holds and dispenses water through the bristles) to jack-of-all-trades round brushes, but now quill brushes are my personal choice for loose watercolors.

Sometimes they are called "mop" brushes, and they come in all different shapes and sizes; most are typically made with soft hairs and an absorbent belly, so they can carry a lot of water and pigment. The synthetic-hair versions are a wonderful alternative to expensive natural-hair brushes.

Quill brushes handle differently than the more common round brushes—learning to use them can be a fun challenge. Once the learning curve is over, however, you will be thrilled by what they are capable of! Quills unload water fast, so you have to keep it moving, which makes this brush great for expressive strokes. I prefer the versions where the brush tip has a fine point when wet, so I don't have to change to a small brush.

It's worth buying and experimenting with a small quill first, as they can still carry a surprising amount of water. Note that the sizes of quills are numbered differently than round brushes. For example, my size 2 Jackson's quill brush is just slightly larger than my size 14 Daler-Rowney round brush. You can just as easily use a slightly larger round brush, if you prefer, for all the exercises in this book.

Dip Pens + Nibs

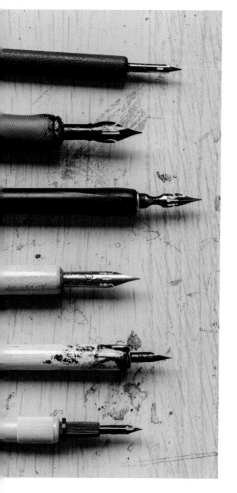

The most common application of dip pens is for calligraphy, but they are also regularly used by comic and illustration artists to get more line variation and add expression to their art. I like to add ink lines and marks, as the density and weight of the line helps communicate areas of light and shadow.

Dip pens do not store any ink in them but need to be dipped into ink every few lines of drawing. Nibs have two tines that come to a point. Applying pressure to the nib causes the tines to separate. This splitting of the nib allows the ink to flow down either side of the tines, so the more they separate, the wider the line that is produced.

Nibs can vary in shape and size, and the metal they're made from affects their degree of rigidness. A flexible nib can produce more line variation than a stiff nib. However, too much flexibility can be difficult to control, so it's best to experiment and see what's most comfortable for you. It will likely take a while to familiarize yourself with several different nibs and find a selection you enjoy using. Most nibs are inexpensive, so it's worth buying several or buying a nib and handle set.

It would be really beneficial to practice a page of doodles or drawing lines on printer paper when you buy any new nibs. This will give you a sense of what type of line can be produced when you vary the pressure or hold the pen handle at different angles or move it in different directions. And also try to get into the habit of adding ink lines from left to right in a piece if you are right-handed, and from right to left if you are left-handed.

Most dip pens come coated in wax to prevent tarnishing. To remove the wax, place the nib in a small bowl and pour just-boiled water over it and leave for a minute. This will melt the wax to allow the ink to flow freely. Dip pens are also simple to clean, even when used with permanent inks, like India inks. You can remove the nib from the nib holder and place it in hot water, then scrub it with a toothbrush.

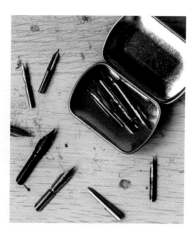

Paper + Sketchbooks

Finding good-quality paper that works for you can be tricky. Although watercolor paper has an important role in the quality of a painting, please don't be intimidated by expensive materials when you're starting out. I think it's a good idea to have a collection of papers in different textures and prices so you don't face the prospect of ruining costly 100% cotton paper.

I have separate pads, papers, and sketchbooks for different uses, like client artwork or just-for-fun sketches or drills (like some of the warm-ups covered in this book). Brands I enjoy using personally are Hahnemuhle, Arches, Fabriano, Winsor & Newton, and Daler & Rowney.

Watercolor paper is available in three different surface textures:

Hot-Pressed has a very smooth surface, as it is pressed through hot metal rollers during the manufacturing process.

Cold-Pressed, or Not, is slightly textured and is the most commonly used watercolor paper by artists. During the manufacturing process the white sheets of paper are pressed through cold metal rollers. It is a general-purpose paper that will suit most techniques.

Rough watercolor paper has a noticeable rough texture.

The weight of the paper is an indication of its thickness. For example, 72lb, or 150 gsm, paper will be light and thin. The most popular weight for watercolor is 140lb, or 300 gsm, which is what I recommended for the projects in this book. The heavier the paper, the more water it will be able to take without warping.

There are also two main grades of watercolor paper: artist quality and student quality. Artist quality, sometimes known as archival paper, is acid-free and designed to endure. Papers that aren't acid-free will become yellow and brittle over time. If you are a beginner or just practicing, then student-quality paper is fine. I very often use this quality of paper, as I do practice an awful lot and, as I sometimes scan my finished sketches, they don't necessarily need to last ten years.

You can buy watercolor sheets individually or in a pack. Watercolor pads are great for painting outdoors or for practicing, as they are bound on one side, which allows you to easily peel off each piece of paper, or you can flip over and start on a fresh sheet.

Using a sketchbook instead of single sheets has advantages and disadvantages. Although I'm well known for working in sketchbooks, I do also work on separate sheets of paper.

For some, the disadvantage of a sketchbook is that a sketch can be there forever, whether you are satisfied with it or not, unless you want to tear out a page. I actually think it's great to look over older work in sketchbooks in order to learn from it and improve. A flip through my sketchbook reveals improvements from year to year, or even month to month, and it's very encouraging. A learning curve is never straight, and work that is less than perfect is a reminder that we learn as much from our mistakes and messes as we do from our successes.

My sketchbooks are not filled with finished artwork. Mainly they are for developing ideas or playing with a technique, rather than anything that's intended for display. And you can certainly use a sketchbook for any and all of the projects in this book.

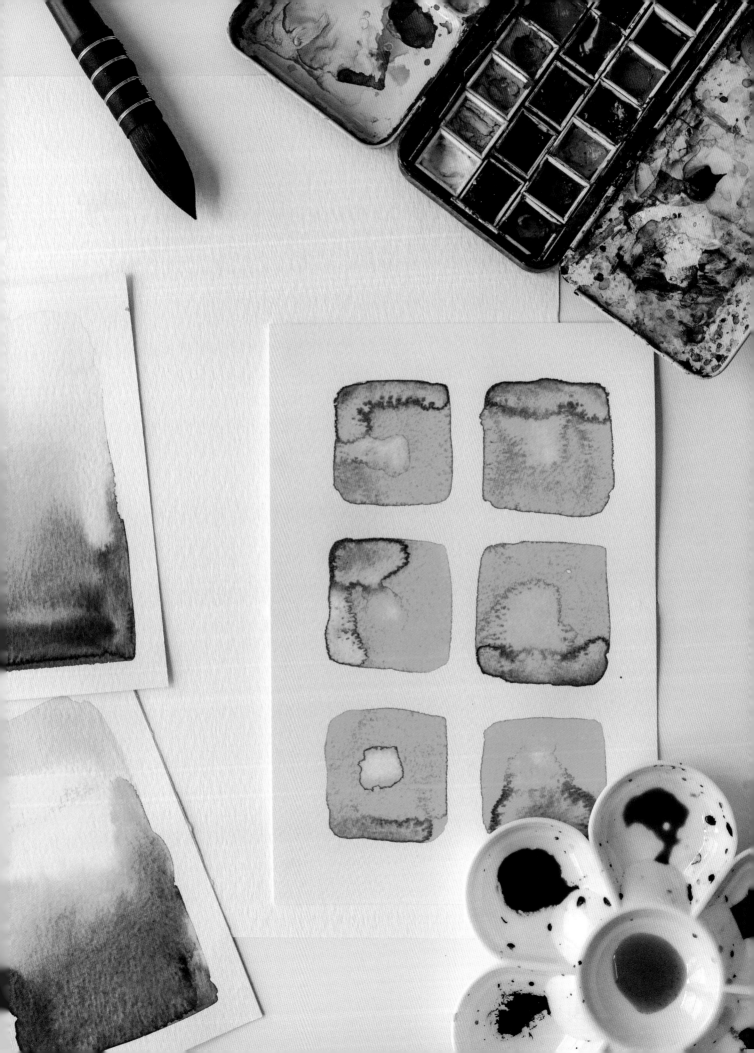

2

The Flow State

If you've ever heard someone describe a time when their performance—whether musician, sportsperson, or artist—excelled and they were "in the zone," they were likely describing an experience of flow. Cultivating flow is a concept describing those moments when you're fully immersed in whatever you are doing, including painting and drawing. Overall, there is an overriding sense of happiness.

What Do I Mean by Flow State?

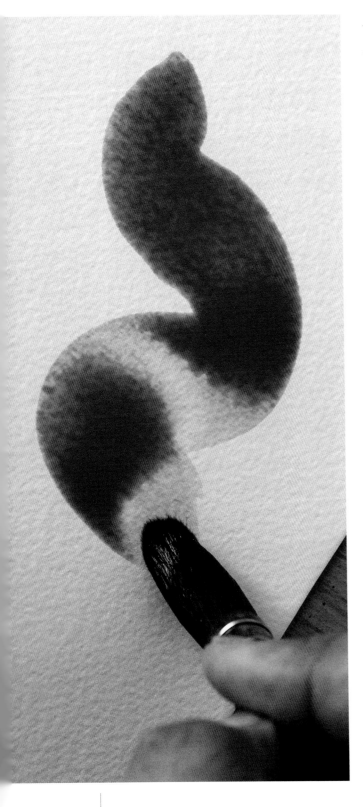

The concept of flow state was popularized by positive psychologist Mihaly Csikszentmihalyi. He felt that "the best moments in our lives are not the passive, receptive, relaxing times . . . the best moments usually occur if a person's body or mind is stretched to its limits in a voluntary effort to accomplish something difficult and worthwhile." If the activity is something we enjoy and are good at, we achieve a flow mental state—and it can leave us feeling ecstatic, motivated, and fulfilled.

When you're giving your full attention to an activity or a task you are passionate about, such as painting, and become totally immersed in it, you may find yourself creating the conditions necessary to experience a flow state of mind. For me, some of the characteristics of a flow state include time slowing down or speeding up, effortlessness and ease and complete concentration when painting. Often, thoughts of stress, worry, and self-doubt take a back seat when I paint, and it seems the hand holding the paintbrush knows exactly what to do.

This feeling adds to my general sense of well-being and a lasting sense of happiness and fulfillment, which is why I love painting with watercolors so much—it's just the absolute pleasure that comes with being in the moment and doing something that I'm passionate about.

Tips for Leaning into Flow

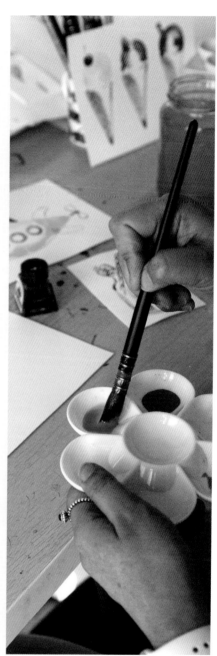

- Ensure there is silence and, as far as possible, no distractions when you are about to paint—for at least the next twenty to thirty minutes. Close your social apps, hide your phone in a drawer, and make sure you're working where you won't be distracted.

- Before you begin drawing, close your eyes and count five slow breaths. Stillness and silence are powerful for quieting the mind.

- Focus on the process of painting by staying mindful.

- Don't think about the end goal. Focus is on the process, paying attention to every brush mark you make, how it feels as it glides across the paper, watching the pigments slowly blending into each other, and waiting for them to dry. For that time, only the art project in front of you exists.

- Choose to paint something tricky (but not too tricky!). You can prepare to achieve your flow state by setting challenges that aren't too hard or too easy, but just right. The aim of stretching yourself is to push for something new that fires up your imagination, ability, and skills so you open up creative possibilities. The sweet spot for flow is somewhere between your comfort zone and your panic zone, but feels within your reach.

Characteristics of Loose Watercolor

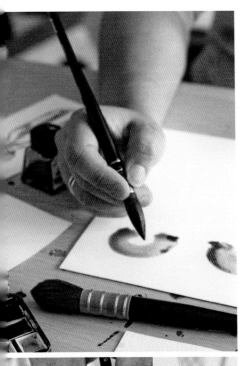

You may have heard creatives talk about painting in a "loose" style and wondered what it actually means. Like many things in art, the term "loose" can be subjective, so I'm offering you my version, based on how I like to paint. For me, this painterly style is highly expressive and more about enjoying the process than trying to faithfully reproduce a subject that is very true to life. When I first started painting in watercolors I'd get lost in the details and become rather obsessed with trying to make my painting look exactly like what I saw.

The nature of watercolor makes it hard to control—instead of fighting it, I want to teach you how to embrace these idiosyncrasies and let go of the final outcomes. So, we are required to trust the whole art-making process, including the fear of making "mistakes," and see whatever the results as a chance to learn. Working loose feels quite exploratory and sometimes experimental, so it boosts our natural curiosity to keep exploring and expanding our creativity.

From my own experiences as a self-taught watercolorist, my sketches became much looser after I gained confidence, so my strokes became freer, and I let them do the work instead of "over-painting" areas. The size of my brushes increased and I started to embrace and include the happy quirks of watercolors, such as blooms where the pigments are allowed to run. I often leave areas of paper unpainted to convey highlights. And when I knew I'd be adding a few ink line details near the end, there were opportunities to really push the loose suggestions in watercolor to the limit.

A loose painting may be described as freer, where just the essentials are included to visually communicate and provide enough information for a recognizable piece. One of the keys to achieving a successful watercolor in a looser style is simplicity. I'll show you how complicated subjects can be broken down by reassessing key components and simplifying them. You can train yourself to evaluate which details are necessary and which you can intentionally leave out, while capturing the core essence of your subject. It is much easier to add to watercolors than to subtract.

Learning about selection and simplification are vital, so it's worth spending more time observing and then deciding in the early stages what to leave out. Working this way is very freeing, as it forces us to trust that we have included enough essential details for the brain to understand and identify the subject. It's often much less than you think.

Shown are the main differences between tight and loose watercolors.

DETAILS

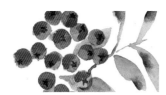 TIGHT: often precise, tidy, and controlled and includes a lot of details

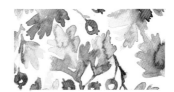 LOOSE: a more relaxed application, with the essentials captured

EDGES

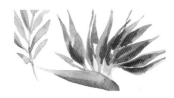 TIGHT: clean, crisp lines with defined edges

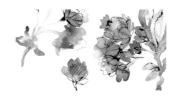 LOOSE: varying edges, from hard to soft, and even lose some edges

BRUSH

 TIGHT: work with small brushes and layers

 LOOSE: use larger brushes with more expressive and intentional sweeps

METHOD

 TIGHT: often working wet-on-dry with controlled ratio of water to pigment

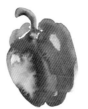 LOOSE: much of the fluidity is achieved by adding wet paint into wet washes and allowing the added pigment to spread out unhindered, causing blooms

Both styles, tight and loose, require skill and craftsmanship, and most artists naturally lean between the two stylistically. When painting watercolors, it's best not to confuse a loose appearance with a loose approach. There are firm foundations, which include considered shape with strong values and contrast in order for the piece to remain recognizable to the human eye.

"Looseness" is something that can be introduced slowly, as often we have to break certain habits in order to trust the materials and our capabilities. Fast and loose may not be for everyone. I can only teach you my approach and preferences with this style of painting. I want to share this with you because it excites me, inspires me, and makes me stupidly happy watching the paint dry.

Loading Your Brush

In this section we will become more familiar with the foundations of loose watercolor. When I've demonstrated my technique in the past, many folks did not realize just how much water was involved, or the vital role it plays in carrying the pigment. Although I use the wet-on-wet technique, most of the watercolor pieces are achieved by a wide combination of techniques. So as you get started, keep in mind that you can combine techniques, as each has its own specific qualities, producing very different and delightful results.

Quill brushes can hold not only water but a ton of pigment with each load as well. What's called a "loaded" or "fully loaded" brush is a brush saturated in watercolor. Applying a wash with a fully loaded brush is an important element that will help different colors mingle on the paper.

1. If using watercolor pans, add a few drops of clean water to each of the colors you need in order to "activate" them. After a few minutes, the paints will have moistened and become sticky, which will allow you to pick up more pigment.

2. Next we need to "prime" the brush by wetting it thoroughly in our water; this will ensure it picks up the paint easily.

3. We have to create the right consistency and value for our needs so we can load it onto our brush. Stroke your wet brush across the top of your pigment if you're using a pan. Bring it to a clean palette and use the same brush to add a large drop of clean water and mix the two together until you have a "puddle." Do not rinse out your brush.

4. Continue to add more brushstrokes of your chosen color, until you get the value of color you are trying to achieve.

5. We can pick up the maximum amount of wash by turning this brush a few times and loading each side. It's now essentially loaded with all the moisture it can hold without dripping off completely.

When you touch the paper, that bead of water will release very quickly and spread across your paper as you move your brush.

The right paint-to-water ratio is directly related to the value and the opacity of the color. It can be tricky to get it right at first, but it will eventually become part of your instinct with enough practice and some observation. Saturate your large brush with juicy paint, and you will be amazed how it automatically frees your mind and loosens up your approach.

When painting with watercolor, understanding the consistency of paint is critical. This is the ratio of water to pigment: You lighten a color by adding more water. The transparent nature of watercolor allows the white of the paper to show through the pigment. Throughout the book I will state how concentrated or diluted the washes need to be for each project.

Color Mixing on Paper

Part of the playfulness of painting loosely is that there's a lot of color mixing on the paper itself, which may be something you're not really familiar with. You've probably seen neat color charts where you take the paints in your palette and mix them with each other to see what colors they make. These charts help you learn how to mix your collection of paints and remember which ones you need to reproduce a particular color in the future. Although they are tremendously useful, these charts are often painted in a "flat" watercolor wash, usually mixed in a palette, so the square has the same uniform color and tone all over.

This short tutorial is aimed at understanding the basics of color mixing on paper and uses analogous shades of yellow, orange, and red. This method isn't supposed to be a hard-and-fast rule, but more for guidance that will allow you to learn from playful studies.

SUPPLIES

>> Watercolor paper *(use inexpensive watercolor paper so you will be less inclined to be precious*

>> Watercolor paints in warm yellow *(cadmium yellow)*, orange *(cadmium orange)*, and red *(scarlet or cadmium red)*

>> Brush *(round brush, #10 or larger, or quill #0 or #2)*

1. Choose a simple subject; I used a satsuma. Create a wash using one shade of yellow and dip the brush in the paint until it's saturated.

2. Using a quick movement, draw a slightly flattened circle shape with your brush, pushing it down quite firmly so all the wash is released. Fill most of the shape using a swift motion but leave an area of the paper unpainted where you see the lightest part of the satsuma. This highlight occurs where your light source (e.g., window) hits your subject.

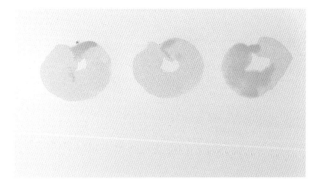 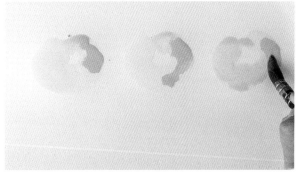

3. Paint two more yellow satsuma shapes spaced across your paper, remembering to leave a bit of the paper unpainted for the highlights.

4. Wait twenty seconds for this to soak in a little. In the meantime, load the brush with a medium wash of orange; then, using the brush tip, add a dab on the right side of the satsuma. The pigment can only flow where there is water.

5. Wash your brush. Now mix a concentrated orange and load your brush with this. Dab this orange on the opposite part of your satsuma shape. Don't push the orange pigment around at this stage. Observe these satsumas as they dry. Make notes of which colors you used and how much time you allowed before adding the next pigment.

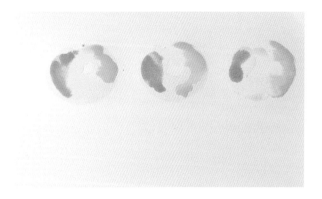

(continued)

Try to work fast, as the pools of color will soak in and become damp patches, and the pigments will not merge together so easily. Because we're using a lot of water, colors will naturally flow and form interesting results. It is often best not to fight this and instead use it to our advantage.

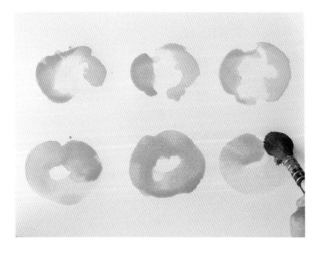

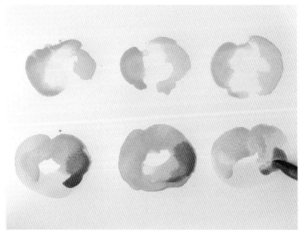

6. In the space below, paint another three satsuma shapes, laying down a wash with orange.

7. Wait thirty seconds, then add a concentrated yellow pigment in a short line that follows the boundaries on the left of your shape. Do the same on the right side by adding a small area of red.

8. Observe what happens as the paint dries and make notes to familiarize yourself in these early stages. Use a green wash to paint small star shapes to represent the stalk near the top of each satsuma.

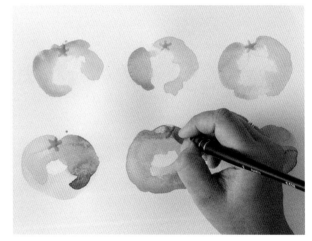

Be mindful that if each section is still wet, your pigments will flow into each other; if there are too many, the colors could become murky, so don't try to blend too many colors. Keep it as simple as you can.

With loose watercolors we have to explore a few other techniques where we allow the pigments to mix spontaneously on the paper, rather than premixing them on a palette. Allowing a few pigments to mix on paper often gives spectacular and unique results. Furthermore, it helps you see which combinations work best to achieve the hues or effects you want when you add extra water.

Wet-on-Wet

With this technique we'll apply a layer of wet paint to wet paper. Or you can add more paint to an existing area of paint that is still wet. Either way, the paint will blend into the first layer with subtle changes of color, creating the soft yet spontaneous effects watercolors are known for.

The slight unpredictability of a wet-on-wet technique can teach us to let go and allow the paint to do what it needs to, which can put off a lot of beginners. However, as watercolor paint will only flow where there is water, there are means of "controlling" it. The main source of control is using moisture to guide and constrain paint pigments. Judging the behavior of paint using wet-on-wet can be achieved through:

- the wetness of the paper

- the load on your brush

It's important to find the right balance of wetness—both paper wetness and brush wetness—to manage the reaction of the paint on paper. When the paper is very wet the paint will spread dramatically; when the paper is drier the paint will hardly spread. With experience you can learn how to manage water and make it do what you want. Try these simple exercises to help you with this task.

ZONES OF WETNESS

If you create a defined area of wetness, and keep an eye on the level of paper moisture, you can achieve lovely soft-edged shapes with wet-on-wet techniques.

1. Paint a square of clear water roughly 2" x 2" (5 x 5 cm).

2. Dab a few drops of paint within the perimeter of the wet paper.

3. Observe how some of the paint cannot spread beyond the damp area.

4. Repeat steps 1 and 2 using a circular area of clean water. Add a few drop of paint within the perimeter of the wet circle and see the extent at which the pigment moves within that circle.

It's best to be mindful of the amount of paint on your brush and the level of paper wetness to achieve different rates of diffused shapes of color. And remember, watercolors dry a tiny bit lighter.

The other two types of useful watercolor washes to know are graded and variegated washes.

Graded or graduated wash: This has a gradual, smooth change in tone, often from dark to light. We can use this technique to paint skies or backgrounds of landscapes.

Variegated wash: This is a blend of two or more colors that can vary in tone in various places.

You might like to stretch watercolor paper if you are using a 140lb/300 gsm watercolor paper or lighter, or if you will be applying a heavy watercolor wash to your paper. Stretching your watercolor paper first prevents the paper from buckling. You can place your watercolor paper flat against a wooden board and tape all the edges down with masking tape. However, if your style of painting uses very little water you will have less buckling and might get away without stretching your paper.

WET-ON-WET GRADUATED WASH

With this quick exercise, as you move down the paper each new stroke should have less pigment and more water in the wash, so it becomes pale at the bottom. Hold your paper at a slight angle to help the pigment and water mix as you introduce more water.

1. Lay down a rectangle of clean water on the paper. Load your brush with a concentrated wash and lay down brushstrokes horizontally across the top third in a wet rectangle.

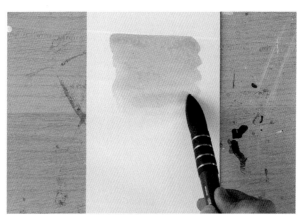

2. Dip your brush into the water and paint a stroke that overlaps the damp edge of the previous wash, so that the boundary between the two washes blends together.

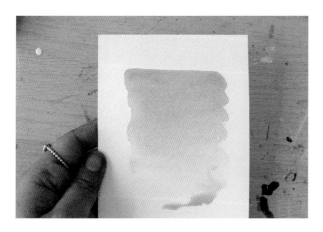

3. It helps to tilt the paper slightly and use gravity to pull the paint downward.

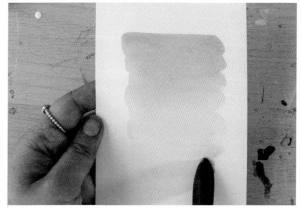

4. Add more water to your brush color to desaturate it and paint another stroke, again overlapping the previous edge.

(continued)

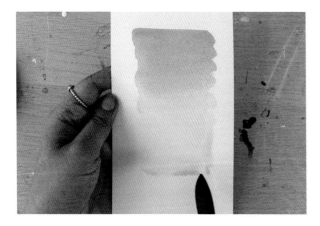 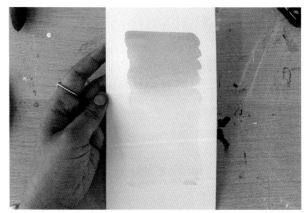

5. Continue down the paper until you get to the bottom and use only water for the last stroke.

6. You can wipe off any excess paint or water using the tip of a dry brush if you don't want a backrun.

A backrun is a feathery-shaped bloom that occurs when excess fluid flows back into a damp wash. See more on page 34.

You might also like to try another graduated wash by applying clean water to your paper to make it moist, then laying down your color. This results in a softer version, as the pigment will diffuse more. Prewetting the paper in this way is sometimes referred to as "priming."

Experimenting with Wetness

Be mindful how much water is on your paper and how much water is in your brush. The outcome of any wet-on-wet technique depends on how damp the specific area of paper is, as well as how concentrated or watery the paint mixture you're using is. So it's great to practice creating a wide range of paint mixtures, from watery, translucent washes to heavily pigmented mixes, and see what happens when they are placed on papers of varying dampness.

VARIEGATED BLENDING WITH WET-ON-WET

This is another popular technique for mixing two or more colors together to create a nice blend of colors. This type of wash can serve as a sunset backdrop or even a mountainscape.

You can either wet the paper first for a very soft blend or paint the washes onto dry paper, which is the technique shown here.

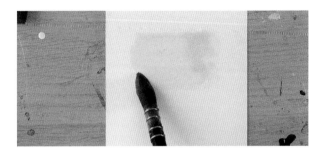

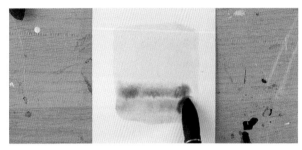

1. Load your brush with yellow wash and apply it to the top half of the rectangle.

2. Before the paper dries, load your brush with blue wash and apply paint so the strokes overlap the bottom of the yellow section by about ¾" (2 cm).

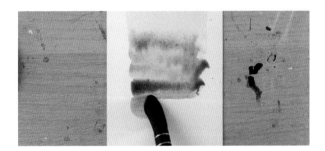

3. Then continue to the bottom of your rectangle with the blue wash.

4. You can tilt the paper to help the mixing process. If the colors don't move, there's not enough water on the surface.

5. The colors will mix and blend together on the paper, creating a beautiful blend of new colors!

Tilting wet-on-wet watercolor can create drama and cool effects in your paintings, through the movement of the paint on the surface. If necessary, to encourage movement, you can tilt the paper in both directions.

DRYING TIMES

The level of wetness of the paper has a big influence on the results produced with wet-on-wet techniques. Over time, I've learned to judge paper wetness by observing specific stages of water soaking into the paper and the different effects on paint behavior.

- In an offshoot of the wet-on-wet, we can, for example, vary the amount of water or know when to add more pigment as the watercolor dries. It's a very fine balance that comes with practiced observation and knowing how your materials will behave to encourage certain outcomes.

- It's really important to pay attention to the drying stage of your painting after the wet stage. There are also four drying stages in a wash: wet, moist, damp, and dry. The timings are only approximate, as various factors, such as painting watercolor in different seasons or with different materials, can affect drying time.

These levels of wetness range from totally soaked to completely dry, and there are four specific stages of wetness. These stages exhibit the following characteristics:

Wet, when there is visible standing water on the surface of your paper and in some areas it has started to flow. You can tilt the paper to let the pigments merge at this stage.

Satin/low-gloss, when the water has soaked into the paper and has a "satin" look where the wash was applied. There is plenty of moisture. This is a good stage to do wet-on-wet. This stage is approximately four to seven minutes after the first application.

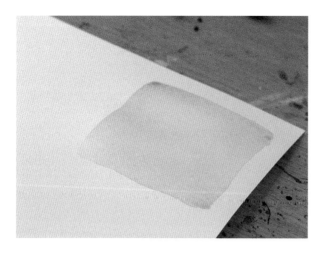

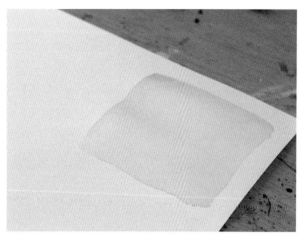

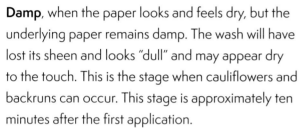

Damp, when the paper looks and feels dry, but the underlying paper remains damp. The wash will have lost its sheen and looks "dull" and may appear dry to the touch. This is the stage when cauliflowers and backruns can occur. This stage is approximately ten minutes after the first application.

Dry, when the paper is dry to the touch and the paint is unchanged if rubbed firmly. This stage is approximately twenty minutes after the first application. As all moisture has evaporated, you go back to a wet-on-dry technique from this point.

After application, within a few minutes the water will start to soak into your paper, become damp, and start to dry. It's at these stages that watercolor can do some unexpected things, like cauliflowers, blooms, and backruns.

A cauliflower is the stage where blooms and backruns can occur. A bloom is a feathery shape with dark edges; it occurs when you introduce water or a more diluted wash into an area of paint that is damp or still drying, as the extra liquid forces the original pigment aside, creating the irregularly shaped splotches. A backrun is very similar in appearance and is caused by a bead of excess fluid flowing back into a damp wash. Both can occur when your wash starts to dry.

FORCING BLOOMS

Blooms, backruns, or cauliflowers are a common frustration for watercolor artists. But if you learn the conditions under which they happen, you can better control watercolors in the future. I love watercolor blooms, as they add character and depth to my sketches and can be exploited and used for great clouds, foliage and flowers, and seascapes or hills.

In this exercise we will drop plain water into squares of wash at different times to see how different rates of drying affect the outcome.

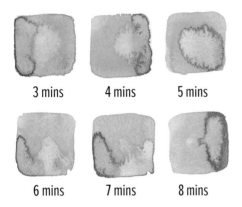

3 mins 4 mins 5 mins

6 mins 7 mins 8 mins

1. You will need an accurate timer. Quickly paint six rough squares, approximately 2" x 2" (5 x 5 cm) in size, next to each other using a medium blue wash.
2. Wait three minutes for the water to soak in, then introduce a drop of clean water to the middle of the first square. Wait another minute, then repeat with square two.
3. Drop clean water into the rest of the squares, with one minute between. It helps to jot down the varying times underneath each square.
4. Observe how the addition of water affects the washes after different lengths of drying time.

The hardness of edges is determined by how dry the underlying wash is. You can also do the same exercise with two pigments, which creates exciting results.

In this exercise we will drop red watercolor into squares of yellow wash at different times to see how different rates of drying affect the outcome.

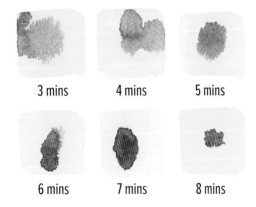

3 mins 4 mins 5 mins

6 mins 7 mins 8 mins

1. Paint another six squares, approximately 2" x 2" (5 x 5 cm), using a yellow wash. Wait three minutes, then introduce a drop of red watercolor to the first square.
2. Wait another minute, then repeat the process with square two. Drop more red into the center of each of the squares, one minute apart each time.
3. When they're fully dry, take a close look at how the addition of the red at different times during the drying process affects how far and how much the pigment mingles with the wash underneath.

You may get different results from what you see above. It depends on several factors, including your materials and climate, or if you are painting on a hot day. It's helpful to know how your paints and paper behave.

Wet-on-Dry

Wet-on-dry refers to applying wet paint onto dry paper, or wet paint onto an area of dry paint. This technique tends to give you more control over your brushstrokes, as the shape will stay exactly as you paint it. If the paint isn't completely dry, the new layer will diffuse into the first. A few projects in this book require this approach, as it allows for more control over the shapes you paint. It's very useful if you need to paint more detailed areas and want to layer for more saturated colors, such as a silhouette of trees, for example.

This is a fun exercise in which layering colors over each other once the previous layer has dried adds depth and richness.

You'll need the following colors:

- Yellow: cadmium yellow or aureolin, medium wash
- Orange: cadmium orange, medium wash
- Red: cadmium red or scarlet

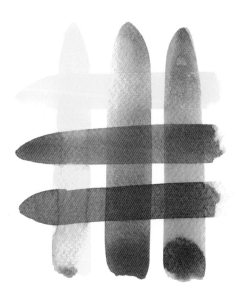

1. Paint vertical stripes of the yellow, orange, and red using a large brush and heavy pressure, with a small gap between each stroke. They should about 4" (10 cm) in length.
2. Let this first layer dry completely.
3. Now, using the same yellow, orange, and red, paint horizontal stripes across the first layer.
4. After this second layer has dried, take a look at the areas where they have overlapped and see the differentiation in color.

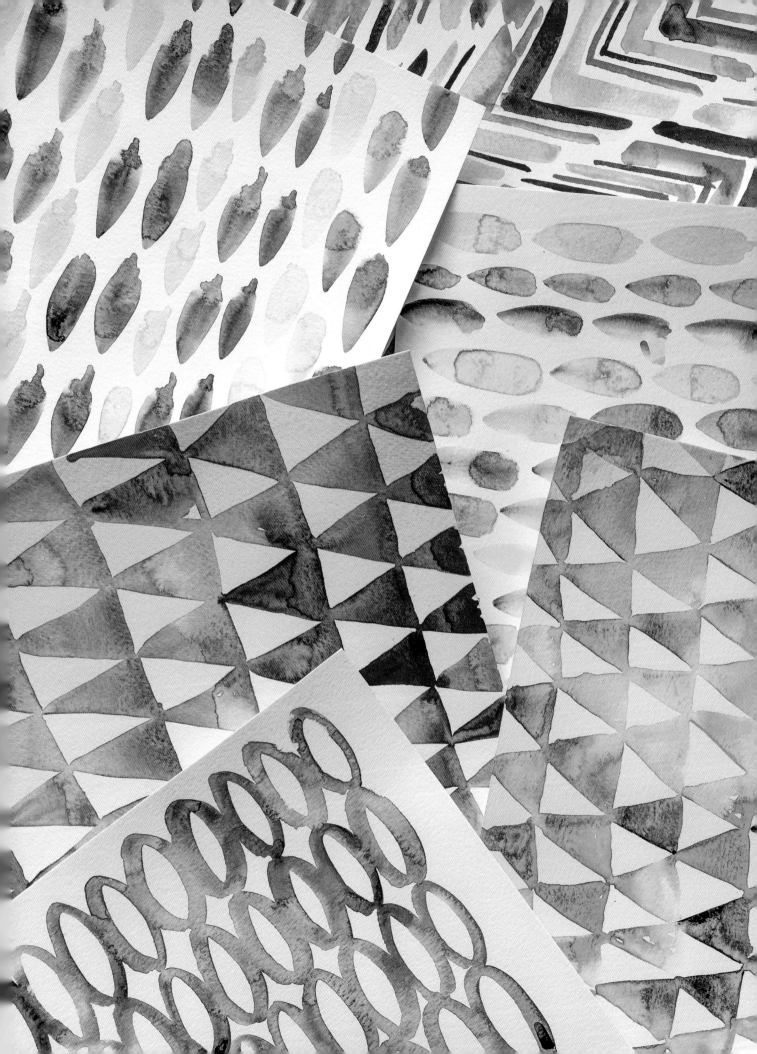

3

Warm-Up Techniques + Exercises

Warm-ups are meant to be fun, and those featured will gently encourage you to take the time and space to set yourself up for success with the projects. Although it's very tempting to skip them, these practice sessions will form the basis of your learning, as well as provide the stepping stones to familiarize yourself with the aspects of loose watercolor. As you lean into working fast, you build muscle memory and adapt your wrist movements. Also, holding the brush a certain way to achieve various shapes will fill you with confidence before trying more complex pieces. These early attempts may look humble and messy, but they are vital to prepare you mentally and creatively for favorable outcomes.

Working Fast

Working fast but intentionally also helps avoid feeling the need to add too many details. If you imagine you don't have time, it helps you focus on the main elements. Painting quickly also means you'll stop sooner—often paintings get ruined because you don't know when to stop.

Sometimes it's worth giving yourself a time limit for each new painting. If overworking a painting is one of your struggles, imposing a time limit may help you get to the essentials without overdoing things.

Please note that painting quickly doesn't mean rushing or being sloppy. We'll talk more about beginning a painting session with intention and mission, without urgency. Often I pause to visualize the next step before letting the brush continue on the paper.

Practicing Brush Control

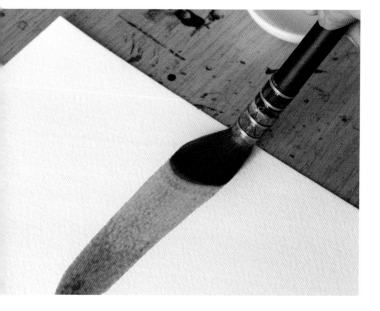

VARYING PRESSURE

Knowing how to use the right amount of pressure is essential, as it influences the size or thickness of your watercolor strokes. By using the tip of your brush, you can achieve finer lines. If you press down firmly, the brush spreads and the stroke thickens. If you lessen the pressure, the stroke will get thinner. I find that a single brush can create all kinds of brushstrokes once you learn how to play with it.

Hand Placement on the Brush

Another important aspect to consider is how you hold your brush for loose watercolors. Holding the brush close to the ferrule (the part that connects the handle to the bristles) gives you more control when creating detailed strokes. However, when you move your hand farther from the bristles you can create much looser strokes. If you hold the brush at the end of its handle, you can create sweeping, expressive strokes. Also, if you use the side of the bristles, you can produce fat and thick lines.

The feel of a fully loaded watercolor brush as it touches and releases pigment on the paper can be exciting, yet scary at the same time. Being free with your brushwork and paint can be a bit intimidating at first, but it can be a lot of fun too. We are going to practice a few exercises that will help us see and recognize what occurs when we vary the pressure of our brushstrokes.

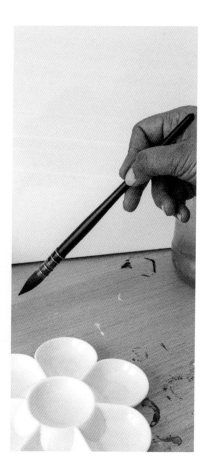

THICK & THIN BRUSH MARKS

I often favor using just the one larger-size brush, and this short exercise will help you sense how much pressure to apply on your brush to make certain sizes of strokes. Although it may seem obvious, the more pressure you apply, the more the bristles will splay out, creating a much larger area to carry your watercolor wash. However, it can take a bit of practice to fully appreciate how certain brushes behave, so it's best to practice these types of strokes first.

SUPPLIES

>> Cadmium yellow, medium wash

>> Sap green, medium wash

>> Prussian blue or viridian, medium wash

>> Round #12 or #14 brush
 or quill #2 or #4

>> 140lb paper (300 gsm) paper

1. Fully load your brush with yellow. Starting on the top-left side of your, paper apply a single stroke using firm pressure so the bristles spread out, then lift up slowly.

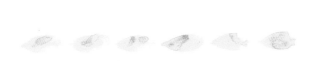

2. Repeat the same stroke horizontally with the same pressure, slowly pressing down and then lifting up, leaving a small gap between each stroke. Reload the brush if needed until you finish that row

3. For the next row, load your brush with green wash and start a new horizontal row just next to the yellow. This time use less pressure in order to make slightly thinner strokes. Continue until you finish that row.

4. Dip the same brush into the blue and start another row, using even less pressure to make your thinnest strokes yet.

5. Continue filling the rest of your paper with rows of strokes applied with different pressures and pigments. You may also want to vary the lengths of the strokes a little, which helps improve your overall control of the brushstrokes and see what's achievable.

6. When it's dry, you'll probably see a few cauliflowers or backflows associated with the different rates of drying.

ZIGZAG LINES

With this warm-up you'll extend the strokes across the paper using a series of zigzags that will force you to change the direction of the brushstrokes. This will help with wrist flexibility, and you'll find out how you prefer to hold your brush at different angles.

SUPPLIES

>> Two different blues *(such as cobalt blue, ultramarine, or indigo)*, medium wash

>> Green *(turquoise or forest green)*, medium wash

>> Round #12 or #14 brush or quill #2 or #4

>> 140lb paper (300 gsm) paper

1. Fully load your brush with a dark blue and make a stroke at a 45° angle downward with heavy pressure, about 1½" (4 cm) long. Now reverse this stroke just to the right so you are left with a shallow V shape.

2. Join another 45° stroke to form the beginnings of the zigzag using the same pressure stroke. Load your brush with more wash if needed to complete the row.

3. Load your brush with a different blue wash and create a thinner set of strokes using less pressure, a little below the first row of zigzags.

4. Add two rows of green zigzag strokes using different pressures. Keep the zigzag strokes parallel to those above. If it helps, turn the paper 90° to paint some of your angled strokes.

5. Continue to fill your paper, repeating steps 1 to 4 and using alternate rows of different blue and green zigzags of different stroke widths. Don't worry if some of your zigzags touch or aren't totally parallel; just enjoy this practice.

6. When you've completed the piece, take a moment to admire how quickly this was achieved. Working fast but mindfully is one of the qualities of loose watercolor for me.

Watercolor painting can be very messy, so it's best to be prepared for accidents. Paper towels are always a handy tool to save you from spills or to blot extra water that has spread on the paper. If you've accidentally wet your paper too much, you can always absorb some excess water by dabbing at the pool of wash or water, carefully soaking it up with the edge of a folded paper towel or with a small clean (dry or slightly dampened) brush.

Practicing Shapes + Water Ratio

Water is essential to watercolor. You loosen and dilute the paint by adding water to it. It is also water that makes watercolor transparent. The paint-to-water ratio is directly related to the paint's value and the opacity. It can be a bit tricky to get it right at first, but with enough practice and some observation it will become easier to gauge the quantities you need.

ROWS OF TRIANGLES

This warm-up exercise will show the relationship between color, from saturated pigment to more subtle, as you add varying amounts of water to the paint mix.

Let's begin with one color to achieve different values.

SUPPLIES

>> Viridian *(or another dark pigment, such as violet or indigo)*, concentrated wash
>> Round #12 or #14 brush or quill #2 or #4
>> 140lb (300 gsm) paper

1. Load your brush with concentrated viridian pigment and paint a triangle, using medium to firm pressure, near the middle of your paper. Quickly dip your brush (not to wash) into clean water and use this loaded brush to create another triangle to the left side of your original, so the bottom corners just touch.

2. You will see the pigment move from one area to another, due to the amount of water on the surface of the paper. Using plain water, paint another triangle to the right.

3. Keep painting more triangles that just touch by adding clean water so you see variations in the gradient. Every so often pick up more concentrated wash on your brush. See how light you can paint a triangle. When the mixture is wet, it will look light and transparent.

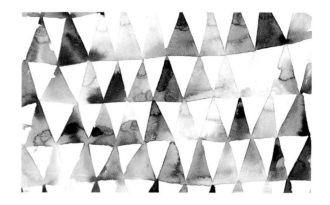

4. Repeat this over and over, adding triangles in rows above and below, until you have filled up the paper. Remember, the wash needs plenty of water—if the mixture is too dry, it will be very difficult for the pigments to flow.

5. The pigments may not always behave as you expect, and I love watching these surprises occur, in order to incorporate similar effects in future art. Working this way also helps you react to the properties of watercolor and build up confidence.

Keeping Your Water Clean

Using murky water when painting with watercolor is not advisable, whichever techniques you're using. So it's important to ensure you're not accidentally dipping your paintbrush into dirty water and placing this water on your paper or paint pans. Dirty water can greatly affect your paint colors and make your piece appear dirty.

When you are working wet-on-wet, you are not only using a lot of water, but also usually working at a faster pace because you're using the dampness of an area to create effects. Some artists use one jar of water to rinse color off their brush and a second jar to load brushes with clean water. I just keep an eye on my jar of water throughout the painting process and change it very often.

OVAL RINGS

This exercise is quite similar to the last, but this time the pigment will only have a narrow band in which to flow. We'll use two colors and see how they respond to varying quantities of water.

<table>
<tr><td>

SUPPLIES

>> Pink and violet, medium wash
>> Round #12 or #14 brush or quill #2 or #4
>> 140lb (300 gsm) paper

</td></tr>
</table>

1. Load your brush with concentrated pink (or violet) wash and paint an oval using a light pressure, so it's a fairly thin line.

2. Then dip the same brush into clean water and create two or three ovals on either side of the first.

3. Load your brush with more concentrated pink and paint an oval next to an earlier version. Dip your brush in clean water and paint more ovals above and below.

4. Keep repeating steps 1 to 3 to fill the rest of the paper. Remember to load up with concentrated washes of color and watch the pigments from each mingle and blend when you add clean water ovals.

5. It's best to wait until the paper is totally dry before making a final assessment of how your pigments behaved in this warm-up.

Warm-Up Projects

These two warm-ups will help you further understand the flow of pigments within the context of the recognizable forms of leaves and apples. It's also worth seeing these as playful exercises to bring into the other elements, like brush pressure, water ratio, and manipulating your brush to create the associated shapes.

LEAVES

SUPPLIES

>> Green *(May or sap)*, medium wash

>> Yellow *(lemon or cadmium)*, medium wash

>> Cadmium orange, medium wash

>> Round #12 or #14 brush or quill #2 or #4

>> 140lb (300 gsm) paper

1. Load your brush with green wash. As you practiced in the warm-ups, place your brush on the paper and apply a downward stroke using heavy pressure to create a leaf shape. Then lift up enough so the tip of the brush stays on the surface of the paper. Still using light pressure, create a thin, curved stroke (going left or right) about twice the length of your leaf. Then fully lift your brush up.

2. To add the rest of the leaves, move your brush to the left of the downstroke. Repeat the press-down-then-lift movement so the bottom end of each leaf tip touches the central stem. Create another two or three like this down the left of the stem. Then add more leaves to the right of the stem.

3. Wash your brush, then load with yellow wash. Start this next sprig to the right and slightly farther down so it still touches and will eventually overlap the green sprig. Create another yellow sprig on the opposite side. Repeat steps 1 and 2, but change the direction of the central stem, so it curves in the opposite direction.

4. Wash your brush and load with orange wash. Repeat steps 1 and 2 to paint three orange sprigs. You now have sprigs that overlap, and the pigments are mingling.

5. Cover the rest of your paper, swiftly working with alternate colors to create a nice balance. Try not to crowd the leaves too much, as the negative space will help define them.

This could be turned into an autumn-themed project using browns, such as burnt sienna, yellow ochre, and cadmium red, or even maroon. You will still learn much about how your watercolor behaves.

APPLES

In this project we create an arrangement of whole, sliced, and apple rings that gives the pigments a chance to play. Starting with the first apple shape, they should grow outward quite randomly and at different angles.

 Along with making up washes for the pink, red, and orange, you will also need a pale peach shade. Mix a few drops of the pink with the orange and quite a lot of water. It may look quite pale, but it can be a base to drop in other pigments.

SUPPLIES

>> Pink *(magenta or rose)*, medium and light wash
>> Peach, light wash
>> Cadmium orange, medium wash
>> Red *(scarlet, carmine, or crimson)*, medium wash
>> Brown *(umber, sienna, or mahogany)*, medium wash
>> Round #12 or #14 brush or quill #2 or #4
>> 140lb (300 gsm) paper

1. Load your brush with a strong pigment of the pink and draw the outline of an apple, using light pressure on your brush.

2. Wash your brush and load with the pale peach wash. Paint the shape of an apple just to the right of this first one so they just touch and the pigments merge.

3. Add a small drop of orange wash to the middle of the apple shape. Now, using your peach wash, paint a circle next to the two apple shapes so they just touch. You will see the pigments mingle.

4. Repeat steps 1 to 3 to fill the rest of the paper, alternating between, orange, red, and pink apples and using lots of juicy paint, working as fast as you can. Remember to keep turning the paper at different angles to find a better position as the apple layout grows.

5. Wash your brush in water to clean it and go back to that very first apple outline you created. Applying heavy pressure, in one movement drag the brush down the middle of this apple, so the pigments start running into this stroke. This adds some indication that this apple piece has been quartered. Create the same quartered appearance to the outline of other apples.

 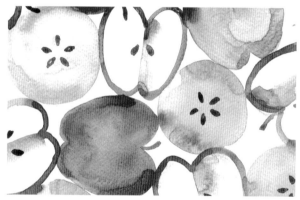

6. Let the washes soak for a few more minutes. At this stage you may wish to drop clean water in a few places where the paper is damp to force a bloom.

7. When it's totally dry, mix a wash of brown. Using the tip of your brush, gently add five seed shapes to the middle of every circle slice and two seeds in the middle of the apple outlines.

If you are new to watercolors, consider using a limited, or even monochromatic, palette. Monochromatic means painting in only one hue or color. If your painting is limited to light and dark, this forces you to focus on the important shades, or tonal values, of your piece. This will allow you to get used to the way things mix with each other. Once you start to gain control over the paint, you can move on to more complex color schemes.

Introducing Expressive Ink

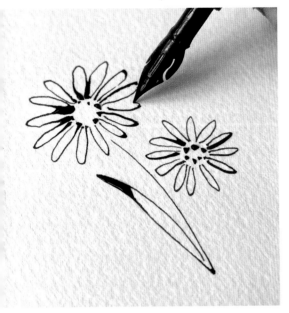

I love using ink, as it can add an incredible amount of contrast to a drawing. It also gives you the ability to add greater definition and details to your sketches.

Although the watercolor takes up the vast majority of the page, it relies on the input from the ink. Imagine if you took away the entire watercolor layer—what you're left with wouldn't quite make sense, as the ink cannot tell the story on its own. But if you didn't fill in with ink there's a sense it's not complete. This watercolor-and-ink combination is a partnership.

So, in that regard, the watercolor layer can be much more underworked than what you may be used to. In fact, I've found that this two-step approach alleviates some of the overworking I sometimes encounter, as it's like you are given a second opportunity to "make things right." The ink doesn't always have to follow the contours of the watercolor that you've laid down; it can work independently if you think it needs adjusting to communicate better.

It's important to recognize that there is no fixed ratio of watercolor to ink. It's a very organic process in which I gauge the amount of ink that might be needed from one piece to the next. I use ink to emphasize contrast, as the density and weight of the line also helps communicate areas of light and shadow. Sometimes I might add extra ink lines to fill up negative space.

When beginners start, the ink lines can be awkward, with little character or liveliness to them. As we learn how to vary the pressure we apply along the stroke, we can infuse these lines with more dynamism and bring them to life. You need to vary your line width if you want a visually dynamic drawing.

I think using ink helps you develop confidence and patience, and you have to be mindful of every mark you put down. Unlike graphite, if you make a mistake with ink, you'll either have to figure out how to cover it up or accept it.

Before you get started on serious inking, spend some time practicing making different marks on scrap paper. Try these simple exercises to help you familiarize yourself with the varying line widths that can be created and the many ways they can be achieved when applying different pressure. You will also gain knowledge of when to dip the nib in more ink. Aim for lines 1" to 1½" (2.5 to 4 cm) long.

INKING EXERCISES

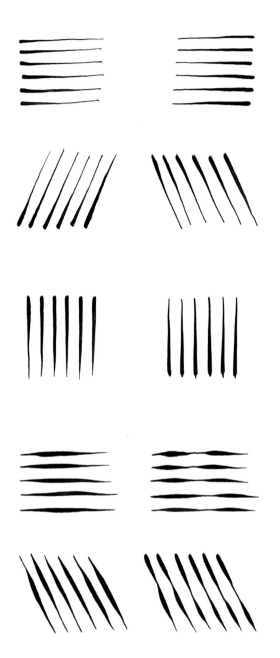

LEFT/RIGHT

Start on the left if you are right-handed, and the right, if you're left-handed.

1. Press down firmly, then decrease the pressure.
2. Start with light pressure, then increase the pressure.

DIAGONAL

1. Make a stroke on a diagonal, starting from the right and using gentle pressure; increase the pressure while bringing the stroke to the left.
2. Make the opposite diagonal stroke using heavy pressure from the left, then downward to the right as you decrease the pressure.

UP/DOWN

1. Starting at the top, use heavy pressure, then lighten the pressure as you continue the downstroke.
2. Starting at the top, use light pressure, then increase the pressure as you continue the downstroke.

IRREGULAR PRESSURE

1. Start on the left with gentle pressure, increase the pressure mid-stroke, then decrease it again as you extend the stroke to the right.
2. Start on the left with gentle pressure, increase the pressure mid-stroke, then decrease it; increase the pressure again, then decrease the pressure again as you extend the stroke to the right.
3. Create diagonals, starting with light pressure, then increasing it halfway through, and decreasing it again as your stroke extends to the left.
4. Create more diagonals, starting with heavy pressure, decrease the pressure, then increase it, then decrease it again as your stroke extends to the right.

For all the projects in this book I recommend BROWN ink, such as peat brown, nut brown, or sepia, as it harmonizes better than black with most paint colors.

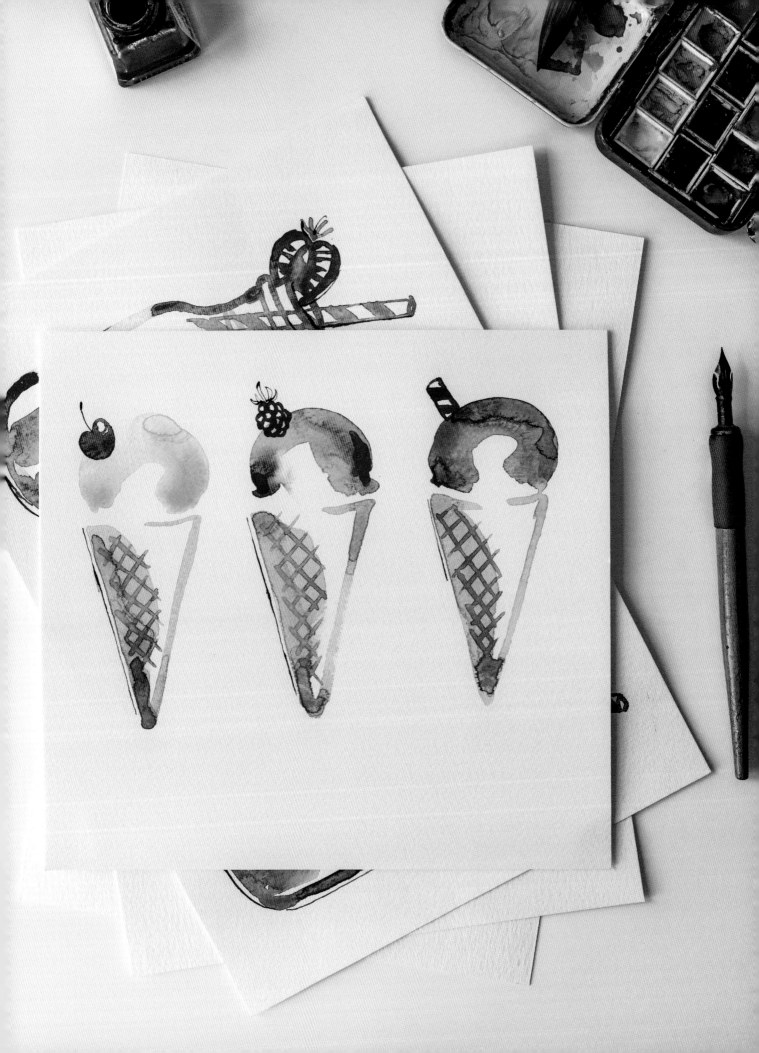

4

Food + Drink

Food and drink are some of my favorite subjects to paint—there's just so many different kinds to be inspired by. When my journey with watercolor began many years ago, fruit and vegetables appeared often in my early sketchbooks, as they can teach us so much about shape and contrast. They are still my go-to subject when I want to relax and explore natural colors.

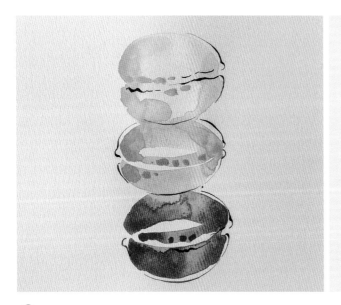

SUPPLIES

>> Cadmium yellow, medium and concentrated washes

>> Cadmium orange, medium and concentrated washes

>> Opera rose (pink), medium and concentrated washes

>> Round #12 or #14 brush or quill #2 or #4

>> 140lb (300 gsm) paper

>> Pen and ink

Macarons

The macarons stacked on top of each other make for a delicate piece as the pigments gently mingle.

1. To create the top part of the first macaron, fully load your brush with the yellow wash. Apply with firm pressure to make a shallow arch shape.

2. Follow up with a thinner stroke underneath in a very gentle inverted arch so the two parts join. But be sure to leave an area of paper unpainted.

3. Load your brush with more yellow. Leave a gap of about ⅕" (5 mm) and, using one movement and heavy pressure, add another stroke directly underneath. This will form the bottom half of the macaron.

4. Wash your brush thoroughly, then dab on paper towels. Then fully load your brush with orange wash. Create another shallow arch directly underneath the yellow so they just touch. That will cause some of the pigments to start merging.

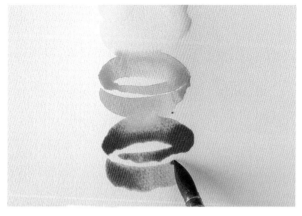

5. Repeat steps 2 and 3 using orange wash.

6. Then wash your brush and fully load it with pink wash. Repeat steps 1 to 3. Let the watercolor dry completely.

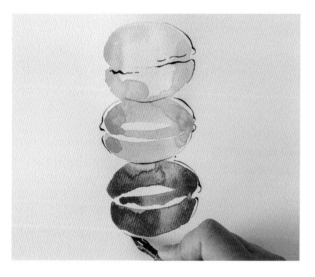

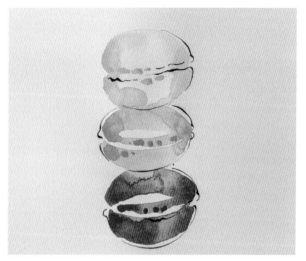

7. Now apply an ink line with a light touch to add extra information, like the "lip" that sometimes occurs on macarons. Add some line to help define the bottom of each macaron (these areas are often in shadow). Also pick out some of the texture using a bolder line, but very sparingly, just to give an indication where it occurs in the middle.

8. Add very concentrated pigments of each color. Dab a few spots on the left side of each macaron for contrast, concentrating on the areas where the filling would sit.

When elements such as macarons are stacked, take a moment to consider the direction of the light so the highlights and shadows remain consistent. The area where the light hits the object first will be lightest, and it will cast a shadow in the opposite direction.

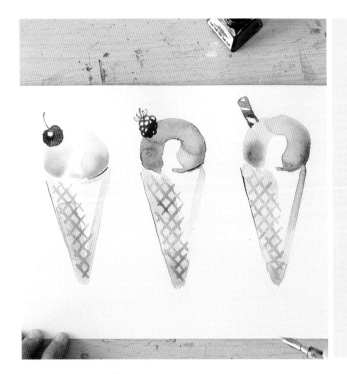

>> Phthalo green or a turquoise blue with a drop of lemon yellow, light and concentrated washes
>> Pink *(crimson or carmine)*, light and medium washes
>> Brown *(burnt umber or maroon brown)*, light and medium washes
>> Yellow ochre, medium wash
>> Red *(cadmium or vermillion)*, medium wash
>> Round #12 or #14 brush or quill #2 or #4
>> 140lb (300 gsm) paper
>> Pen and ink

Ice Cream

These cute little ice creams in a row are really simple but so effective. The secret to the cones is painting the crosshatching texture once the first layer of paint has dried (wet-on-dry).

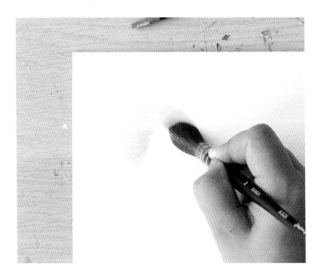

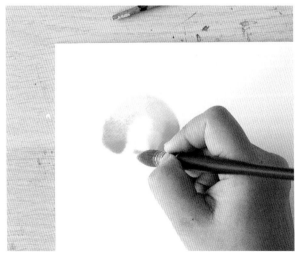

1. Start on the left with your first scoop of ice cream. I chose mint, which has a light blue/green wash applied with heavy pressure to create a slightly fuller semicircle shape. Start on the left (base of the scoop) and loop up and around, coming down on the right.

2. Load your brush with a concentrated green, then dab a few drops toward the bottom on either side of the scoop. Use the tip of your brush to bring some of this pigment around to the area where the ice cream sits on top of the cone.

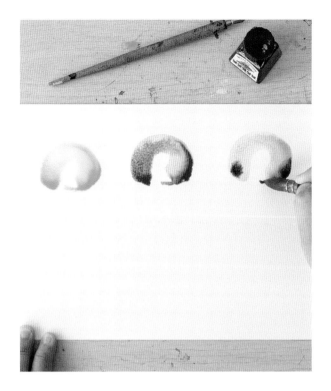

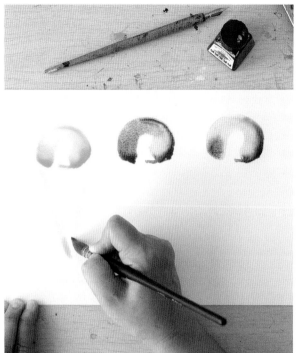

3. Repeat steps 1 and 2 with your pink and brown for the strawberry and chocolate ice cream.

4. To make the cones, load your brush with yellow ochre and apply with medium pressure to create a V shape under each scoop. It should be twice the height of your scoop.

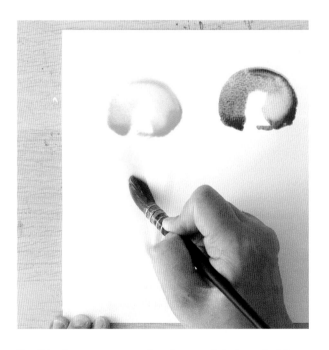

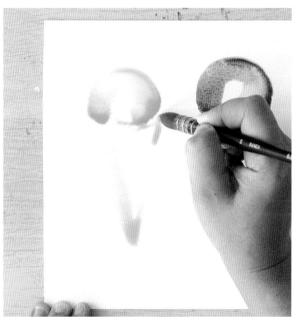

5. Using heavy pressure, make a downward stroke against the left side of this V shape on the first cone.

6. Add a short stroke from the right side of the top of the V, just underneath the scoop, to give the impression of a rim.

(continued)

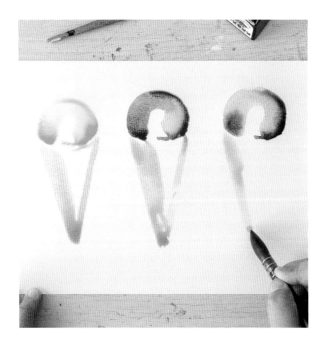

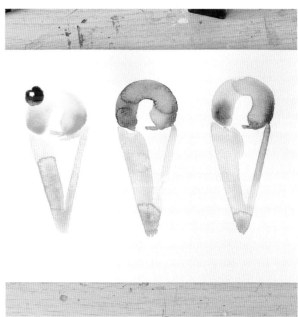

7. Repeat steps 5 and 6 for the other two cones. Then wait for them to dry.

8. Wash your brush and load it with concentrated red wash to paint a cherry. Paint the outline of the cherry on the top left edge of the scoop. Fill most of the cherry, apart from a small highlight where the white paper should show through.

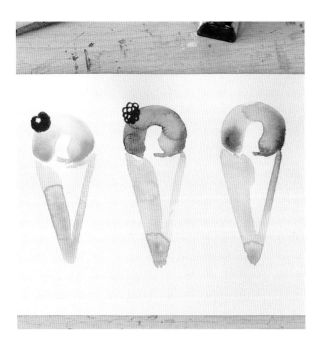

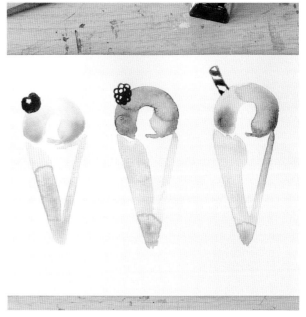

9. Wash your brush. Next load the brush with concentrated pink and, starting on the left edge of the pink scoop, paint little circles close together with the tip of your brush. Continue until you have a raspberry shape. Wash your brush.

10. To paint the wafer roll on the top left of the chocolate scoop, load your brush with the brown wash. Paint two short parallel lines at an angle, using light pressure. Add a few diagonal stripes to the roll.

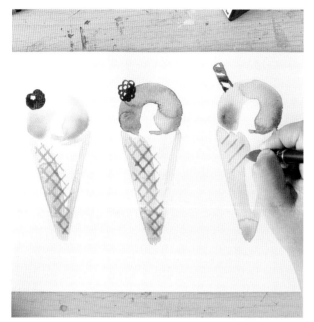

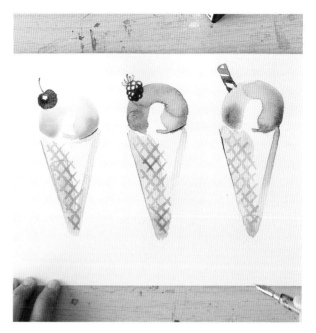

11. When the cones are dry, mix some of the yellow ochre with a few drops of brown. Using the very tip of your brush, create five or six short parallel lines running diagonally down from the left side of the cone. Add diagonal lines running in the opposite direction to create a large crosshatch effect.

12. Use ink to define the left side of the cone. Add the stalk to the cherry and raspberry and add the underside of the wafer roll.

In general, watercolors dry lighter, so applying a tone or shade that's one value darker than the desired effect is helpful. To do this, you also need to add less water or more pigment for the color to remain one shade darker when dry.

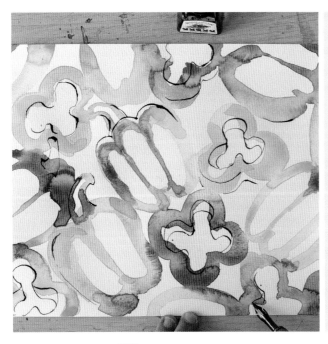

Bell Peppers

In this project we'll create a random-looking arrangement of colorful whole and sliced bell peppers. They have interesting cross sections, whichever way they are sliced, often creating a rough trefoil shape that looks like three overlapping rings, or a quatrefoil shape that resembles four overlapping rings.

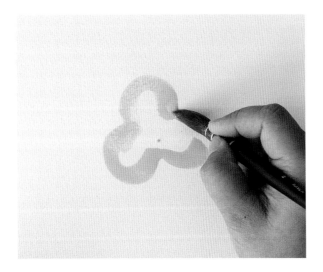

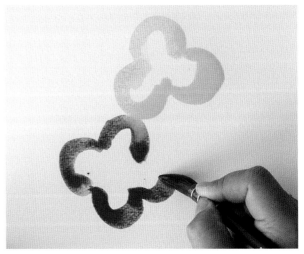

1. Load your brush with yellow and use quite heavy pressure to make a trefoil shape. Start with one inverted, shallow U shape, then paint two other U shapes that join together at 120° angles.

2. Wash the brush and quickly load with red wash. Paint a quatrefoil shape, using four shallow U shapes arranged at 90° each, so they just touch the yellow slice; some pigment will run.

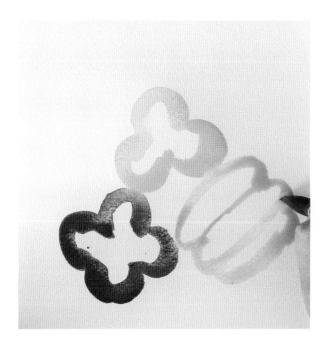

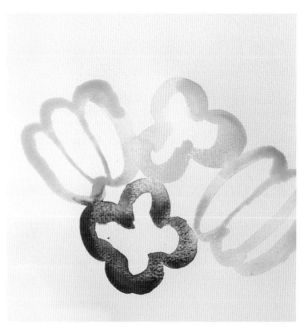

3. Wash your brush, load with green wash, and paint the outline of a whole pepper using medium pressure. Add the characteristic bumpy top and bottom so they just touch the yellow slice, allowing the pigments to merge. Add two thin parallel lines extending from the top to the bottom of this pepper shape to imply the segments.

4. Load your brush with more green wash and paint the outline of another whole pepper, using medium pressure.

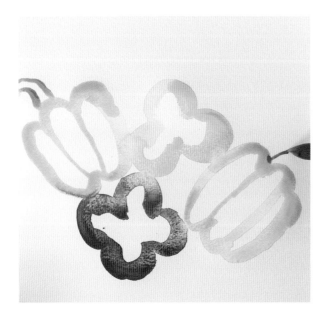

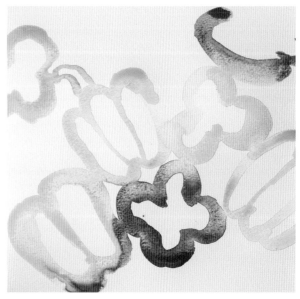

5. Using the concentrated green wash, quickly add an outline of a hooked stem to each green pepper.

6. Wash your brush thoroughly. Repeat steps 1 to 4, moving to fill the remaining space with more sliced and whole peppers.

(continued)

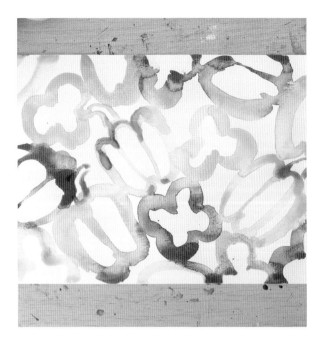 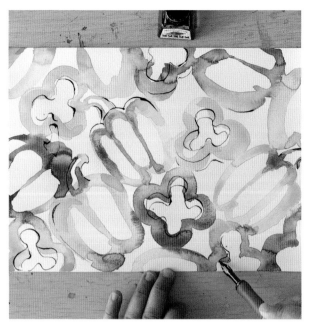

7. Be mindful to balance, or distribute, the red, yellow, and green peppers evenly across the paper. Let the paper dry completely.

8. Use ink to add details such as the inside edge of the sliced peppers to make them more dimensional. Also, consider thin ink lines for some of the edges of the whole peppers and the sides of the stalks.

For multidirectional pieces like this, it's easier to rotate the paper 45° to 90° clockwise and counterclockwise, rather than try to position your body and hand at odd angles. This also minimizes the risk of accidentally smudging areas.

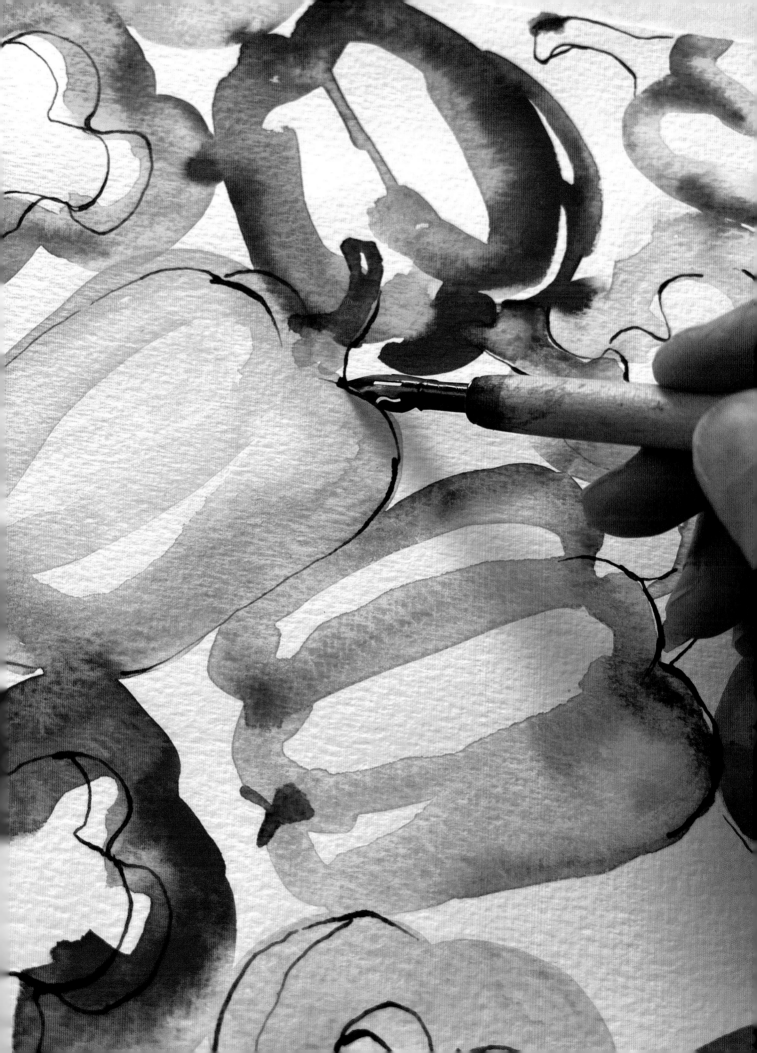

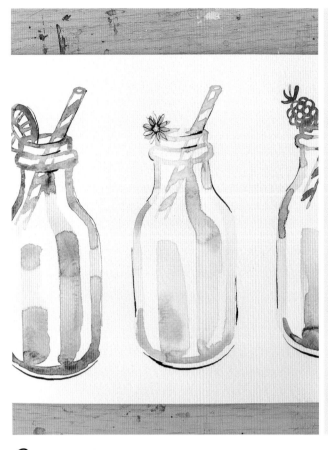

>> Pink *(potter's pink, permanent rose, or any pink)*, very light and concentrated washes
>> Red *(cadmium or vermillion)*, medium wash
>> Green *(sap or Hooker's)*, medium wash
>> Yellow *(Naples yellow or ochre)*, light and concentrated washes
>> Cobalt blue, medium wash
>> Brown *(raw or burnt sienna)*, medium wash
>> Violet, medium wash
>> Round #12 or #14 brush or quill #2 or #4
>> 140lb (300 gsm) paper
>> Pen and ink

Milkshakes

These milkshakes are super fun, with three different colors and flavors, fruity decorations, and accompanying straws.

1. You can choose in which order to paint the bottles. In this example I'll start with the pink bottle, or strawberry. Create the outline of a bottle using medium-light pressure on your brush, starting from the top left. My bottle has a short neck that becomes a little wider (the shoulder) before the main body, which is twice the length of the neck and shoulder combined.

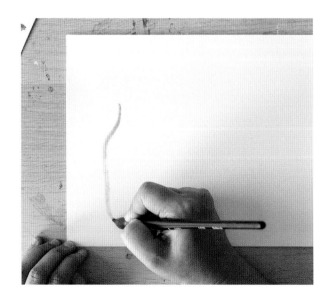

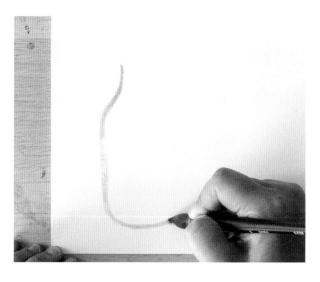

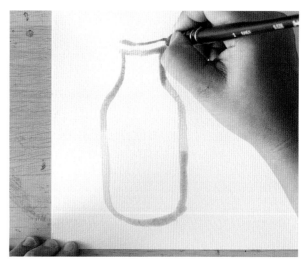

2. At the base of the bottle round the line, creating a shape like a shallow semicircle. Then continue the outline back up the other side, narrowing at the shoulder and neck to complete the top.

3. The collar of the bottle sits just above the neck and is created by painting two slightly curved, short parallel lines with the tip of your brush, joining them together in each corner.

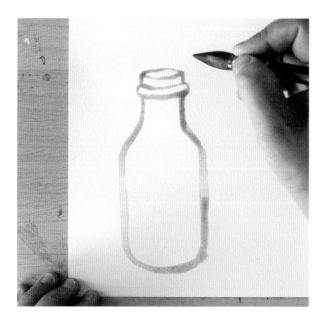

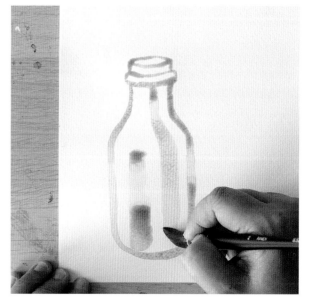

4. Above this collar is the upper rim or lip of the bottle. Follow the lines of the neck upward and paint in two very short marks on either side the same height as the collar. Top this off with a small ellipse.

5. Load your brush with more light pink wash and, with heavy pressure, apply a stroke just to the left of the middle, from the same height as the shoulder to the base. Then add another stroke starting at the right of the middle, underneath the collar. Begin with light pressure on your brush, then steadily increase it as you follow the curve of the shoulder and move down, finishing this stroke at the base of the bottle.

(continued)

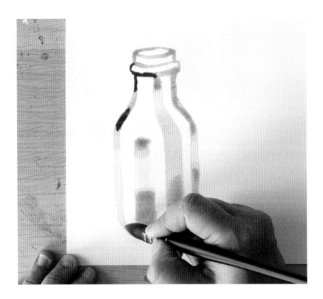

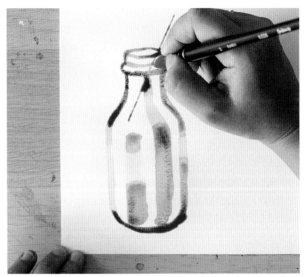

6. To add some contrast, load your brush with a more concentrated pink pigment and drop some of this in the left outline of the bottle, the neck, the shoulder, and the base. Also add tiny drops on the collar, toward the right edge. And a few small drops along the wide strokes in the middle of the bottle too.

7. Dip your brush into more medium pink wash to create the straw. Start at the outer rim and paint a thin line (light pressure) at 60°, extending up the same length as the neck of the bottle. Then extend this line inside the bottle at the same angle until it's near the left shoulder. Paint another thin line parallel to the first, so they're close together. Add a series of diagonal stripes running down the straw but use a light wash where they appear inside the bottle.

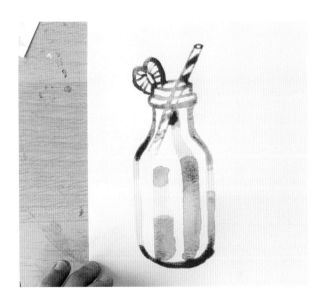

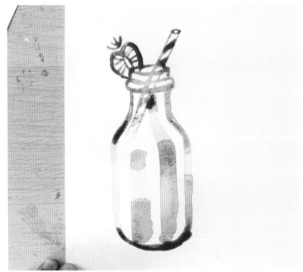

8. For this first milkshake I'm adding a sliced strawberry that sits on the left rim of the bottle. Load your brush with red wash and paint the outline of a strawberry. Fill the middle section with a small lozenge shape in red, with very thin lines radiating outward.

9. Wash your brush, then pick up some green wash and apply it, using very light pressure, in a series of small, angled strokes to make a stalk.

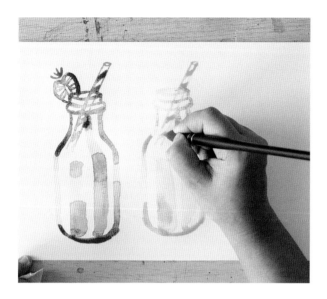

10. Repeat steps 1 to 6 using the yellow wash for the vanilla milkshake. Place a yellow daisy on the rim of the glass and paint a blue straw.

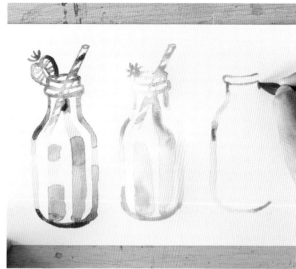

11. Repeat steps 1 to 6 with the brown wash for the chocolate milkshake. Add a raspberry (see page 60 in the ice cream project) and a purple straw.

12. Let all the paint fully dry. Consider adding some ink details to the upper rim of each bottle, where it meets the straw, as well as on the underside of the straws. Where the wash of the outline is very light, ink lines just outside the outline to mimic clear glass. Do this at the base of each bottle as well.

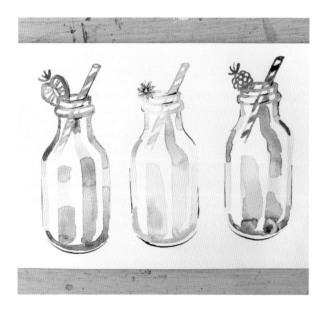

Be intentional with your strokes by pausing between each step to look at how your piece is progressing. Make a mental note of where you might need to add the more concentrated pigment to create more "pop" and contrast. This deliberation helps make pieces seem dimensional.

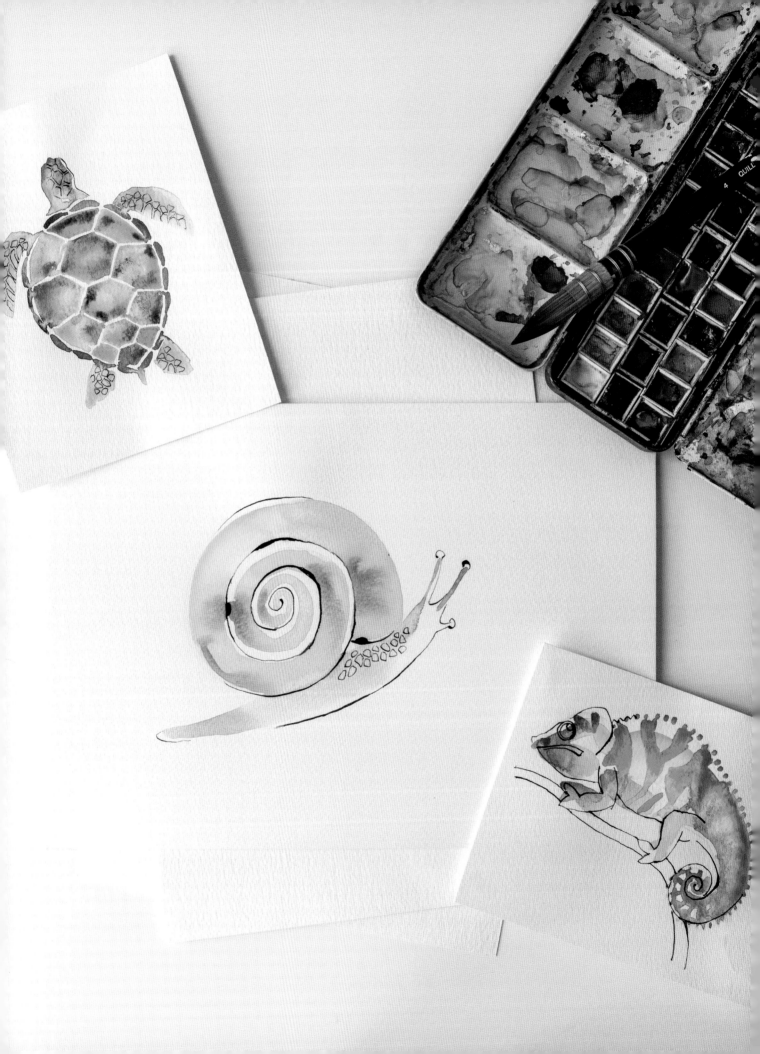

5

Animals

The animal world will always provide endless inspiration for artists, and animals are a great way to improve your watercolor painting skills. The projects in this chapter will provide a balance between including enough details for the subject to read as an animal, while letting the free mingling of watercolors create wonderful results. Staying loose, with no overly complicated elements, will allow you to enjoy the time spent on these projects.

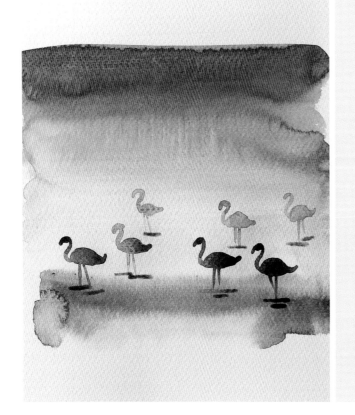

SUPPLIES

>> Red *(cadmium red or scarlet)*, medium wash

>> Yellow *(cadmium yellow or aureolin)*, medium wash

>> Dark blue *(Prussian blue, indigo, or Payne's gray)*, medium and concentrated washes

>> Purple mixture of your blue and red, medium and light washes

>> #14 round brush or #4 quill brush

>> #10 round brush or #0 quill brush *(optional)*

>> 140lb (300 gsm) paper

Flamingos

Silhouettes of these iconic birds at sunset conjure up far-off places. If you've tried out the variegated blending exercise (page 31), this should be pretty straightforward. The final piece will have three bands of color, created using red, yellow, and blue washes. Timing the application of the various washes is an important factor here, in order to create some of the backruns that add to the atmosphere.

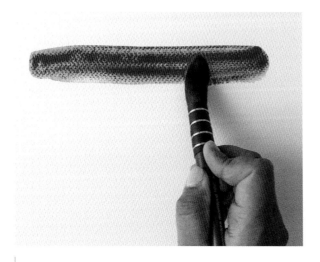

1. Fully load your brush with red wash and, using heavy pressure, make a thick, horizontal stroke across the paper, approximately 6" (16 cm) across. Use the wash on the paper to keep extending the stroke down, using more horizontal strokes to create a red area approximately 6" x 2¾" (16 x 7 cm). Load your brush with more red wash if you need to fill that space.

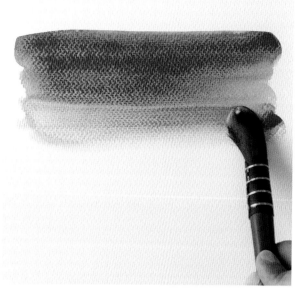

2. Wait for this first layer to soak into the paper. It should take approximately two to three minutes, or when most of the sheen has disappeared.

3. Load your brush with yellow wash and overlap the red wash area by approximately 1" (3 cm). Starting on the left, extend your stroke all the way across so the yellow and red overlap and the pigments start merging, creating orange.

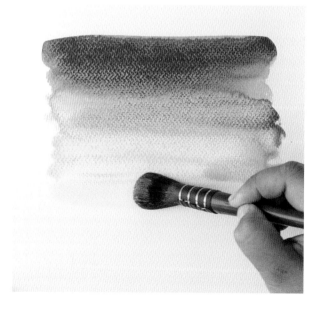

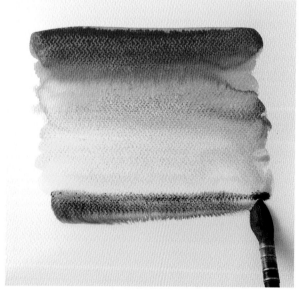

4. Quickly make more full horizontal strokes so this band of yellow-orange is about 2¾" (7 cm) wide.

5. Wash your brush well and load it with concentrated blue or gray. This will represent the lake the birds are standing in. Place the first stroke, using medium pressure, at the very bottom of the yellow band.

(continued)

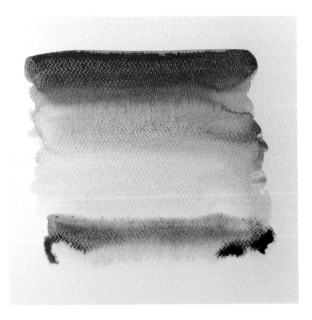

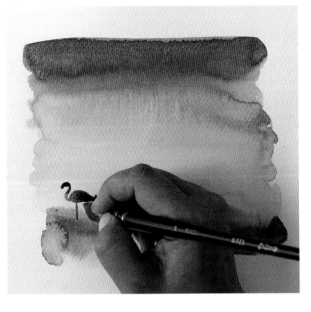

6. Create another blue stroke directly underneath so they overlap and create a band about ¾" (2 cm) deep. Let all the washes dry completely at a slight angle to help the pigments blend and create blooming effects.

7. We will add the flamingos in the bottom diffused, dark-blue section. The flamingos nearest us can be darker, so we will use the medium purple wash. You can use a smaller brush, if you prefer, as the flamingos need to be quite small.

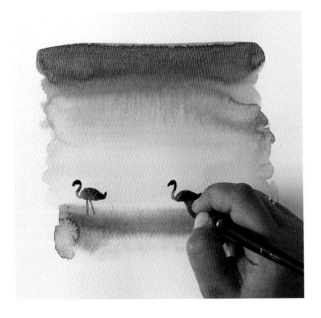

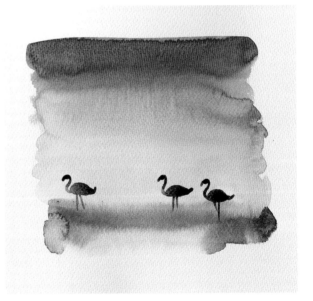

8. Each flamingo is an eye shape, with a tiny flick at the end for the tail feathers. Next, paint their slender necks, which are very thin S shapes that attach to the base of the body.

9. As they are all in silhouette, we don't need to fuss over details, just the shape. The legs are just two very thin lines about the same height as the body and neck combined.

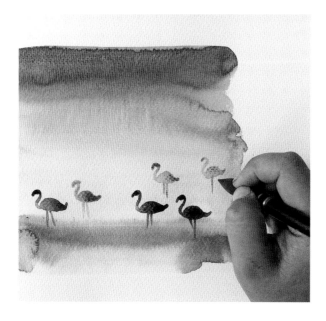

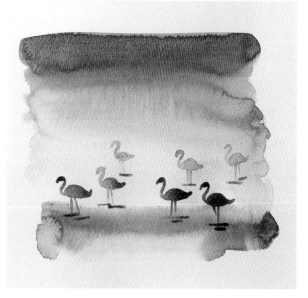

10. Fill in the remaining space between the two sets of flamingos with smaller ones dotted about, as if they are in the distance. Use the light purple wash for these.

11. Underneath each flamingo add a very short dash of the purple wash to imply a shadow, using light pressure.

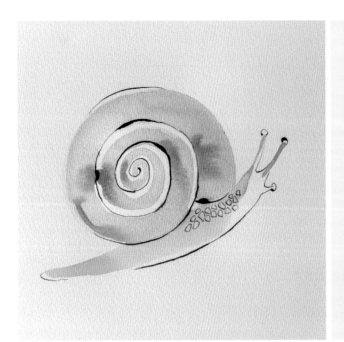

SUPPLIES

- >> Cadmium yellow, medium wash
- >> Cadmium orange, concentrated wash
- >> Purple or violet, light wash
- >> Round #12 or #14 brush or quill #2 or #4
- >> 140lb (300 gsm) paper
- >> Pen and ink

Snails

You can create a series of these snails across your page of all different sizes with other warm-colored shells.

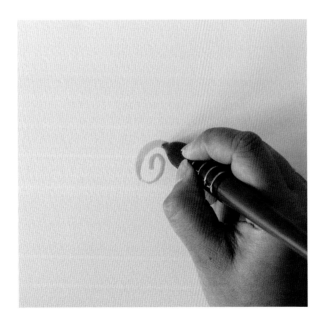

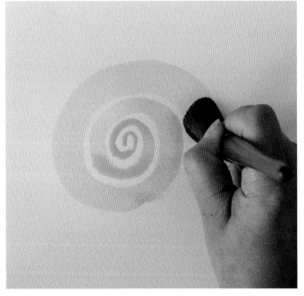

1. Load your brush with the yellow wash. Using the lightest pressure, begin in the middle of the snail's spiral shell.

2. Increase the pressure very slowly while enlarging the spiral in a clockwise direction.

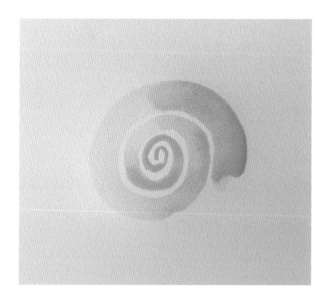

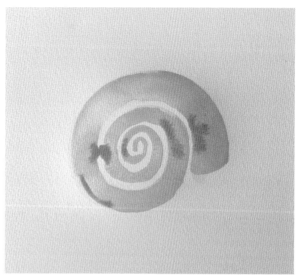

3. Try to leave a small, evenly spaced gap between each round of the spiral, even as you increase the pressure. In this version I went around three times, finishing with the lip of the shell at the four o'clock position.

4. Wait two minutes for this first wash to soak in a bit. Then load your brush with the more concentrated orange wash and add a drop at the lip and at various points along the shell. The pigments can only disperse where it's damp.

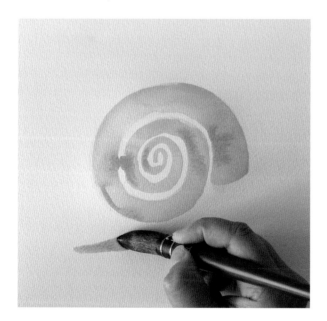

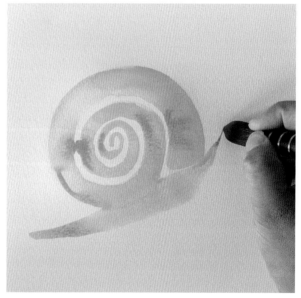

5. Wash your brush and load it with the light purple wash. To create the "foot" of the snail, start below the shell and a little to the left of the outer rim. Start your stroke with gentle pressure and increase the pressure as you glide your brush underneath the shell and lift up as it emerges past the outer right rim.

6. With the brush still on the surface of the paper, decrease the pressure and extend the stroke into a very thin stalk. This will be the "ocular tentacle" with the snail's eye at the end. Create another stalk-like stroke at a slight angle to the first. Let this all dry completely.

(continued)

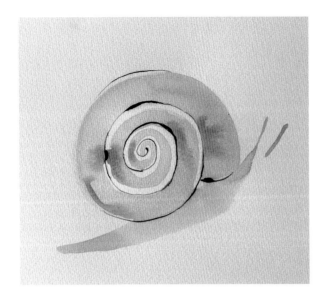 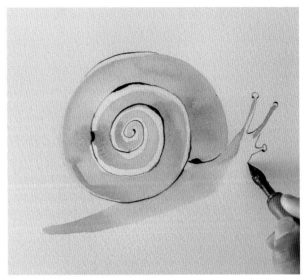

7. The ink details need to be added to the shell, again starting in the middle and following the rough contour of the spiral, including some of the outer rim and lip.

8. Add ink lines for the snail's "tentacles," which need the characteristic bumps at the end. Add some small, irregular-shaped patterns or markings along the foot of the snail as seen on the facing page.

This project requires you to be really flexible with your wrist as you follow a spiral shape and super mindful of the brush pressure as the spiral develops. It might be worthwhile practicing the hand movement for spiral shapes with your brush and plain water on a scrap piece of paper.

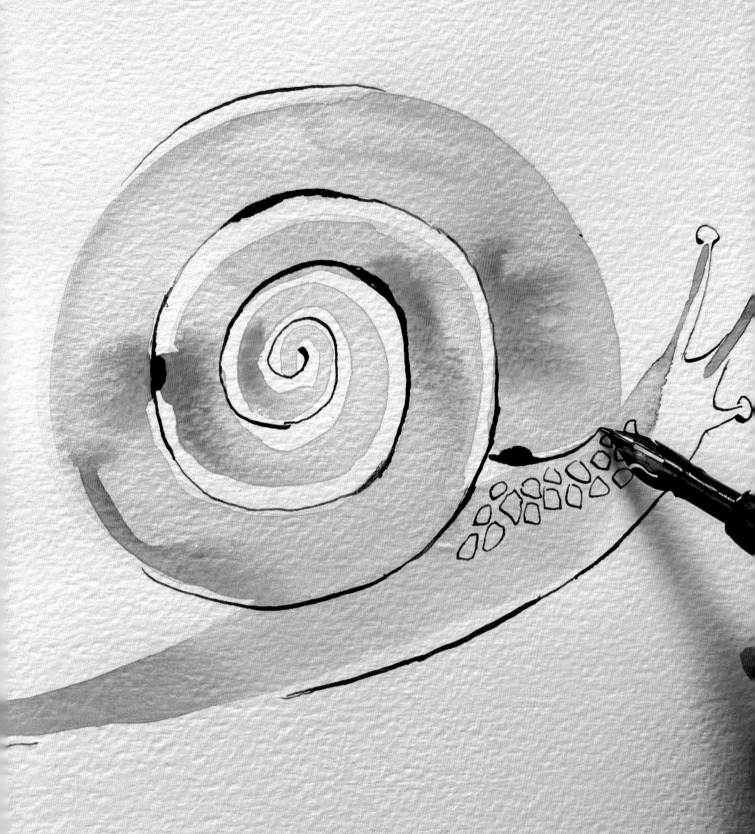

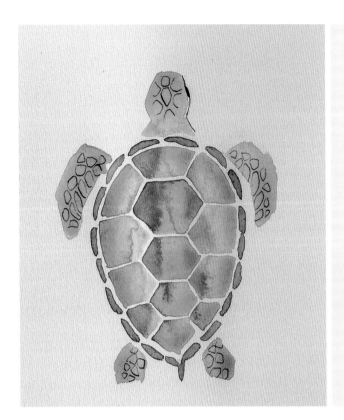

SUPPLIES

>> Cobalt turquoise, light wash
>> Ultramarine, light and concentrated washes
>> Prussian blue, medium and concentrated washes
>> Round #12 or #14 brush or quill #2 or #4
>> 140lb (300 gsm) paper
>> Pen and ink

Turtle

This might look like a complicated arrangement of shapes, but everything slots together nicely like a jigsaw puzzle. The larger hexagons and polygons that make up the shell, or scutes, are perfect for the pigments to mix.

1. Load your brush with the turquoise wash (or any other light wash of blue) and paint a rough hexagonal shape just above the middle of your paper.

2. Leave a small gap, then paint a slightly smaller hexagon directly below it. Then leave another gap and paint an even smaller hexagon.

3. We need to fill in the rest of the "puzzle pieces" of the shell. They need to be arranged so that together they form an inverted tear shape. (If you are unsure, you may like to draw a very faint pencil line to serve as a guide.) Still using the turquoise wash, add a fourth even smaller hexagon below the other three.

4. Add a half-hexagon with a curved upper edge above the largest hexagon. This will start to form the edge of the shell. Next is the left side of the tear shape, which can be filled with four different-sized trapeziums. If some of the shapes touch, don't worry—it will add to the overall effect.

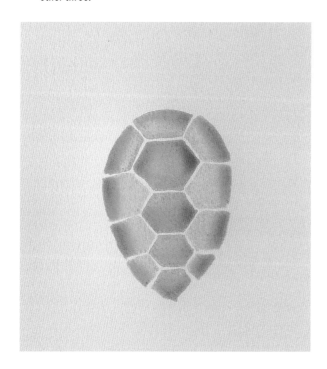

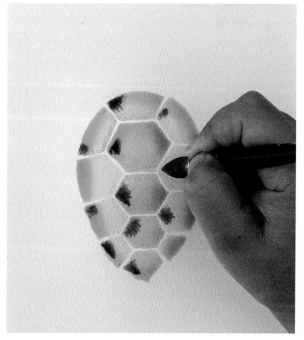

5. Paint the same shapes for the right side of the shell.

6. Pick up ultramarine wash with your brush and, with the tip, add a tiny drop to some of the shapes in the shell.

(continued)

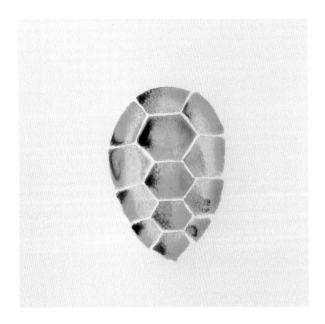

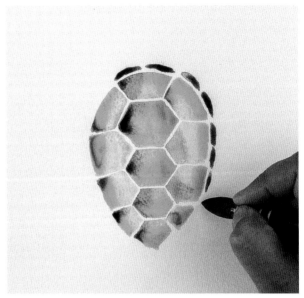

7. It might look like too much of a contrast, but the ultramarine and turquoise will diffuse as they start drying.

8. Load your brush with Prussian blue wash. Using light pressure, add a row of long, thin scallop shapes running around the outside of the shell, following the contour of the tear shape.

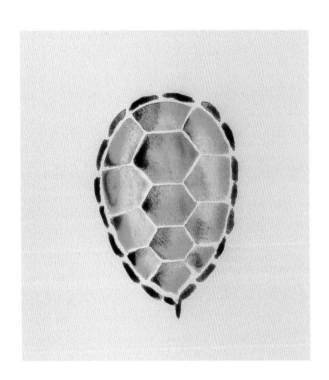

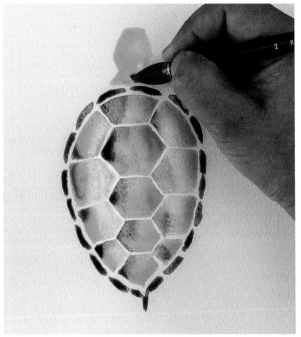

9. When you've completed this outline, add a little pointy tail at the bottom.

10. Wash your brush and load with a light wash of the turquoise to paint the turtle's head. The head is shaped like an elongated pentagon, with the base tucking nicely into the rim of the turtle's shell.

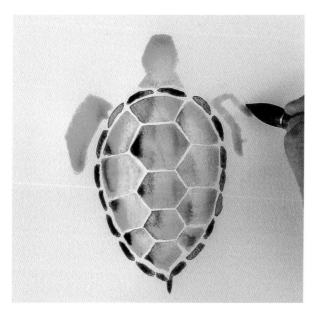

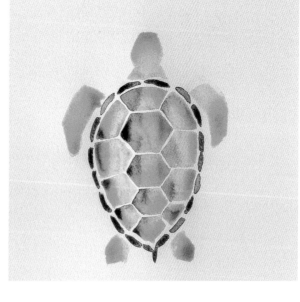

11. Load the brush with more turquoise wash to paint in the front and back flippers. Starting at an 11 o'clock position, close to the body, create a stroke with hard pressure that extends halfway down the body of the turtle. Repeat on the right side.

12. Paint the lower flippers with more turquoise wash. They are half the size of those above and look like pointy paddles. Let the whole piece dry completely.

13. Add ink details in the form of irregular-shaped scales on both sets of flippers and a few on the head.

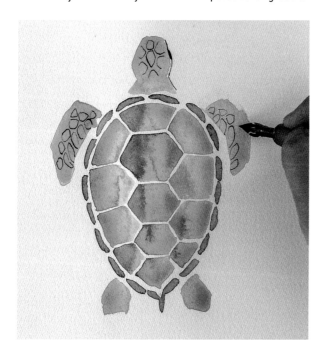

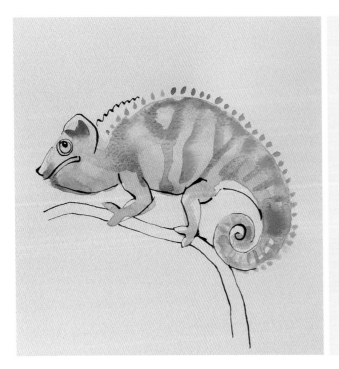

SUPPLIES

>> Lemon yellow, light wash
>> Cadmium orange, medium wash
>> Veridian or cobalt turquoise, light and concentrated washes
>> Round #12 or #14 brush or quill #2 or #4
>> 140lb (300 gsm) paper
>> Pen and ink

Chameleon

I imagine this cute chameleon is sitting on a branch waiting to catch its next meal. This project uses a combination of wet-on-wet followed by wet-on-dry to achieve the distinctive markings. The body of a chameleon may look complicated, but it can be broken down into three different parts: the head is a rough triangle, the body is an oval, and the tail is almost like another version of the snail, with a spiral.

1. Load your brush with yellow wash and use medium pressure to paint a rounded triangle shape that leans slightly to the right.

2. Add the body, using heavy pressure to create an elongated oval that is twice the length of the head.

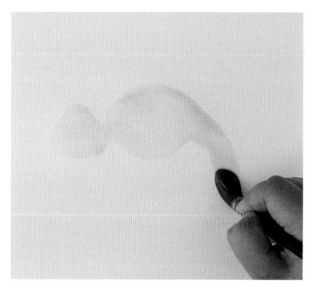

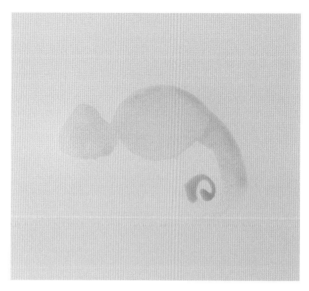

3. Load your brush with more yellow wash. From the right side of the oval, start the tail, using heavy pressure with your brush. Extend the tail to the right slightly, then move your brush down before starting on the actual spiral.

4. Decrease the pressure as the spiral gets tighter and the tail gets thinner.

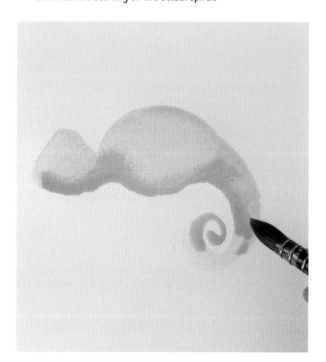

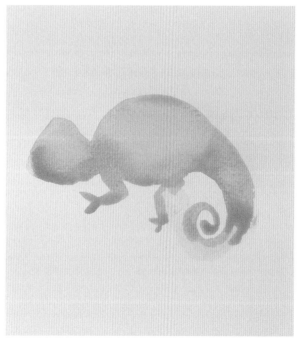

5. Load your brush with orange wash and, using light pressure, follow the contour of the underside of the head and belly, down the tail, and into the swirl.

6. Use the pigment left on your brush to paint the legs, which are inverted V strokes on their sides. Each leg ends in two smaller inverted V shapes.

(continued)

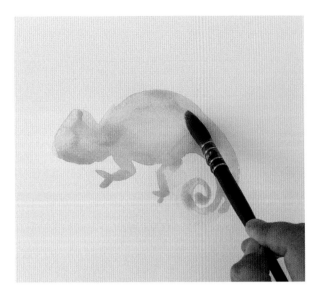
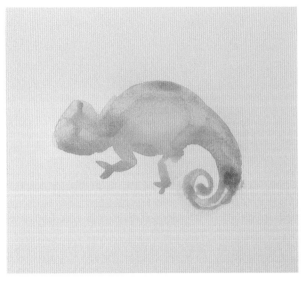

7. Wash your brush and load with the veridian wash to create a continuous stroke starting at what will be the tip of the nose and then gently curving, following the contour of the body and into the tail.

8. Let all the pigments on the paper soak in for three or four minutes until it's just damp.

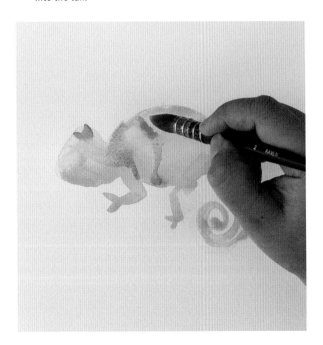
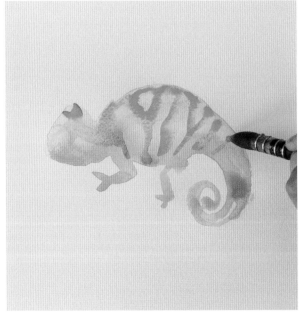

9. Load your brush with veridian for the markings at the top of the triangle part of the head, using two short strokes. Then make a longer downward stroke from the spine to the bottom of the belly. Leave a small gap, then paint in a Y shape from the spine down to the belly.

10. Repeat the single stroke, then the Y stoke along to the right of the body until you reach the tail section.

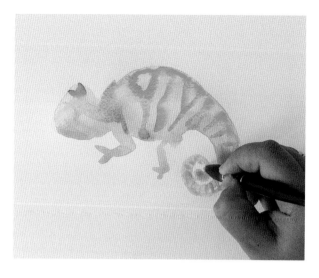

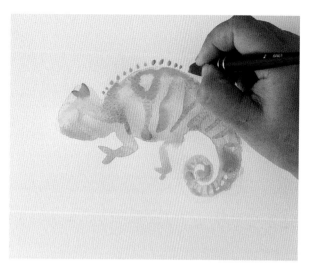

11. You can now make a series of ever shorter strokes as the tail curls around.

12. Load your brush with more veridian, then add a series of very small dots along the back, all the way from the head to the tip of the tail.

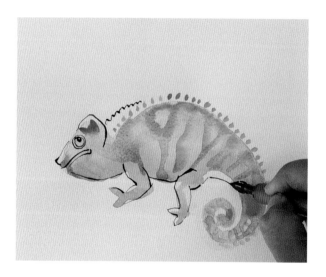

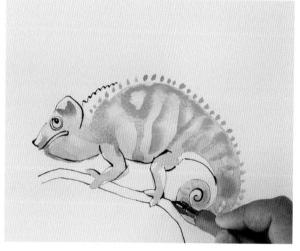

13. Use ink to fill in the features of the face: a big eye with its pupil looking upward and a slightly downturned mouth. Add ink lines to the underside of the body, define the legs, and accentuate the curl of the tail.

14. Using ink, draw the tree branch that the chameleon is holding onto. It needs to bend slightly and be quite thin so it looks like the chameleon's feet wrap around the branch.

When working with watercolor paints, we begin with the lighter colors or washes and then work with the darker values. Because of the transparent nature of watercolors, the white comes from the paper, not the paints. So the green over the yellow wash here appears very vibrant.

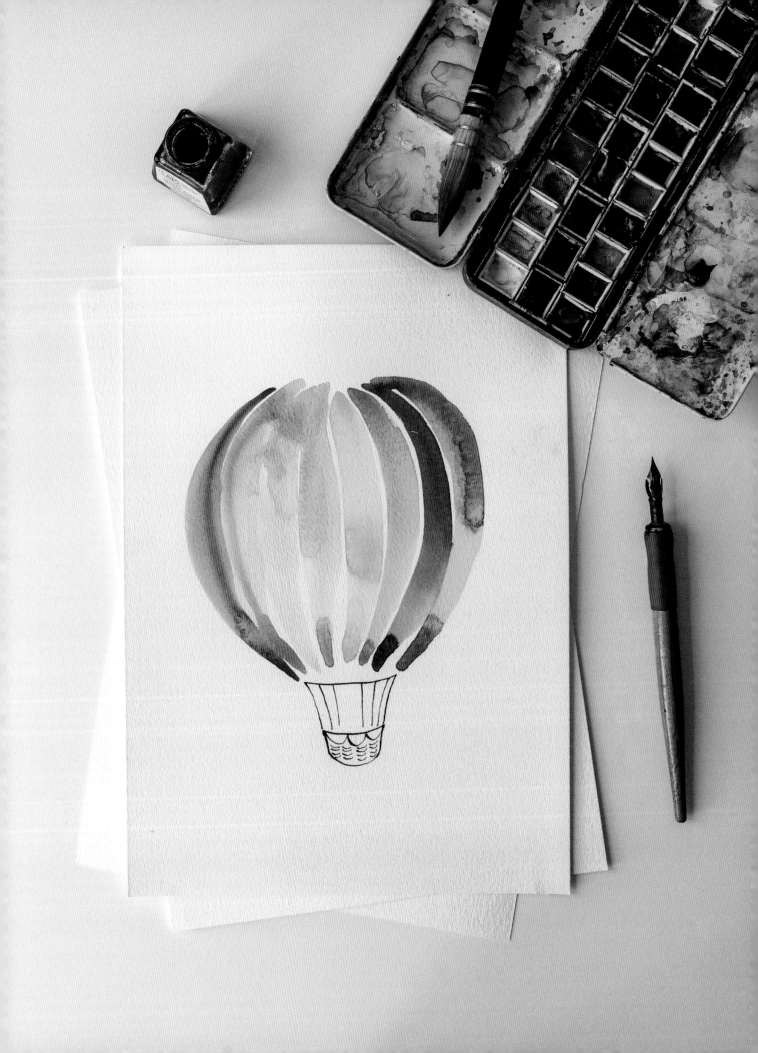

6

Travel

Whether it's travel by air, sea, or land, transport is another subject matter with a diverse range of options to inspire us. Exploring the world can fill us with a sense of freedom and help push our creativity further. These projects are really simple and fun ways to bring some of that inspiration to our art.

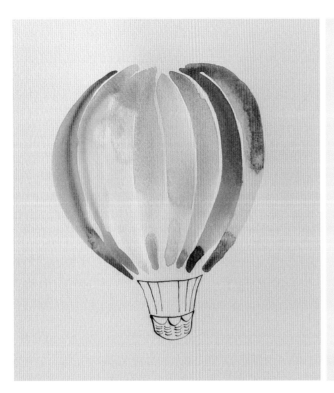

SUPPLIES

>> Phthalo turquoise, medium wash
>> Ultramarine, medium wash
>> Winsor violet, medium wash
>> Opera rose, medium wash
>> Sap green, medium wash
>> Cadmium yellow, medium wash
>> Cadmium orange, medium wash
>> Winsor red, medium wash
>> Round #12 or #14 brush or quill #2 or #4
>> 140lb (300 gsm) paper
>> Pen and ink

Hot Air Balloon

The basic shape of a hot air balloon is an inverted teardrop (with a bit chopped off at the bottom), with the basket and attached ropes in ink lines. Before starting, it's best to have all the different color washes premixed in a palette, as we'll need to load each one onto our brush in quick succession.

1. Fully load the brush with the turquoise blue; starting near the top and just to the right of the center, make one confident downward stroke.

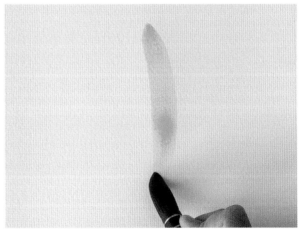

2. To follow the contours of the balloon, start with a little pressure on your brush, then increase it until the bristles of the brush are fully splayed or spread out. Then decrease the pressure toward the bottom of the balloon before lifting up.

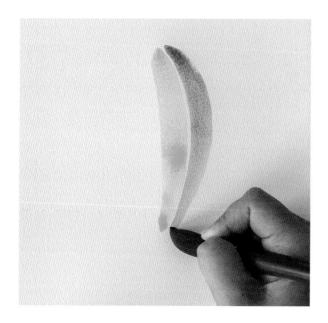

3. Wash your brush. Next, fully load your brush with ultramarine wash and place your brush to the right of your turquoise strip so they just touch. Repeat the same one-stroke movement down, leaving a very small gap between the two colors. Try to make the bottom of this ultramarine stroke the same level as the bottom of the turquoise stroke.

4. The turquoise and blue pigments will likely merge at the top and bottom, and that's fine. Remember to wash your brush thoroughly and dry with paper towels before picking up the violet wash. Start creating a more curved stroke to emphasize the rounded shape of the balloon.

5. Wash your brush well, then load it with the pink wash and add a stroke to the right of the violet. The curve of this stroke will be the most distorted, as it's on the edge of the balloon.

(continued)

It's probably best to change your paint water completely at this stage, as we'll be adding warmer colors to the left side of the balloon. This will prevent the colors from becoming a little muddy.

6. Wash your brush and load it fully with green. Place it close to the left of the original turquoise blue stroke. Again, use one confident downward stroke. Then wash your brush well.

7. Fully load your brush with yellow and start your downward stroke to the left of the green, again leaving a tiny gap. But don't worry too much if pigments flow into one another.

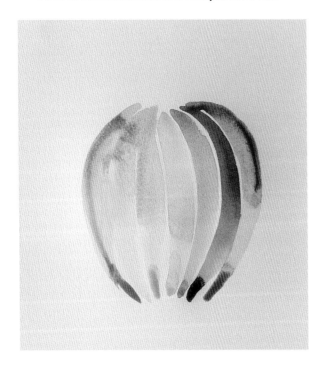

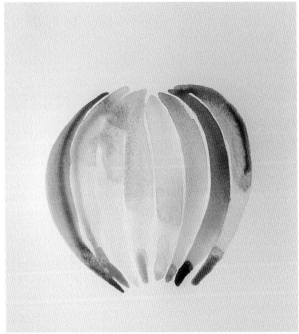

8. Repeat with similar strokes, adding a curved stroke of orange wash.

9. Now finish with a very curved red stroke on the far left. Let the washes dry completely.

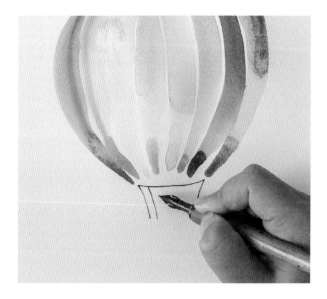

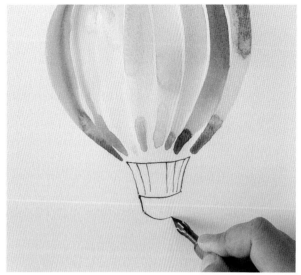

10. Using an ink line, we will add the suggestion of ropes. Start by creating a single, gently curved line that sits just underneath the bulk of the balloon. Then extend six or seven lines downward, about ¾" (2 cm) in length.

11. Outline a small basket shape underneath the ropes by making a small curved stroke under the balloon. Then make an even smaller curved line a little underneath to form the bottom of the basket.

12. Now join these two strokes together so you have a full outline of the basket. Then fill it in using little decorative scallop shapes.

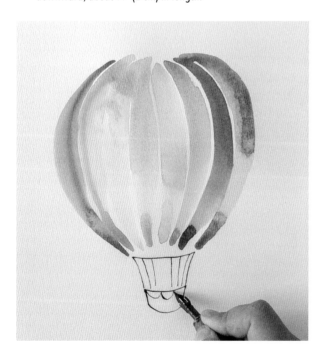

If you'd like to try this balloon on a greeting card, you need to paint it at a smaller scale using a smaller brush. Unfold your card so it's flat, then paint on the right-hand side of the card. If desired, you could add suggestions of pale blue sky or clouds using a variegated wash.

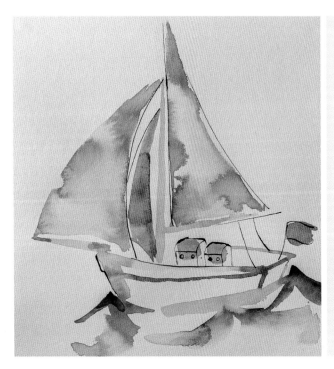

SUPPLIES

>> Ultramarine, concentrated and light wash
>> Cadmium red or vermillion, medium wash
>> Raw or burnt sienna, medium wash
>> Round #12 or #14 brush or quill #2 or #4
>> 140lb (300 gsm) paper
>> Pen and ink

Sailboat

This sweet sailing boat out at sea can be achieved quite quickly, but it does require quite a methodical approach, due to the water-control elements.

1. We will start by creating the surface of the sea where it meets the bottom of the boat; this will be the darkest part of your piece and will give the impression of a deep sea. You should gauge your other values against this. Using a concentrated wash of ultramarine, paint an inverted V and add a short stroke.

2. Load your brush with light ultramarine wash and paint the outline of your hull. Start with a sideways stroke from left to right. On the right, create a rhombus shape for the stern, or end, of the ship, and partially fill this shape in.

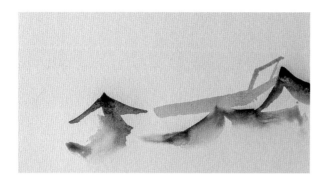

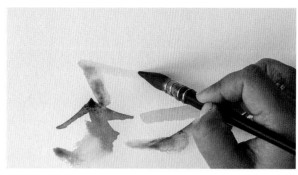

3. Now add more inverted, curved V shapes to represent more waves just in front of the boat.

4. Using the pigment from the first V you laid down on the left, extend an angled stroke to the left, which will be the front of the boat.

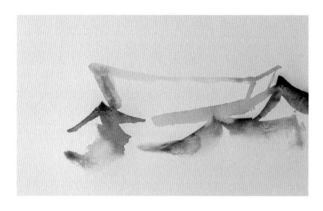

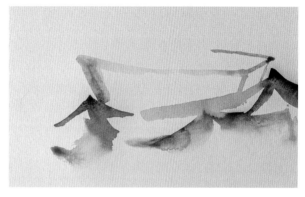

5. Using light ultramarine wash, extend a thin line from the front section to the back of the boat.

6. Then make another thin line, which will be the far side of the boat

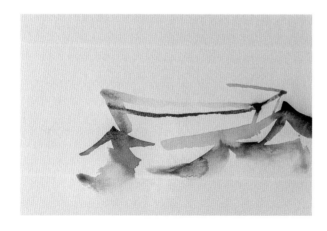

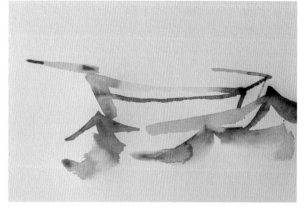

7. Wash your brush well and load it with the red wash. Using gentle pressure, paint a red line from the front to the back of the boat.

8. Wash your brush with lots of clean water, then load your brush with brown wash to add the boom, which is the horizontal bar extending from the front of the boat. Start with light pressure, then increase slightly so you have a stroke about 2" (5 cm) long.

(continued)

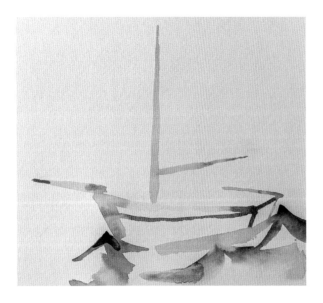

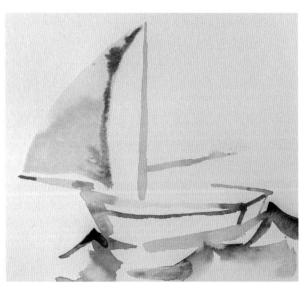

9. Turn your paper 180° as it will be easier for the next step. From the edge of the hull paint the mast using a long stroke, applying medium pressure, then slowly decreasing as the mast emerges. Make the mast the same length as the boat. Next, make a slight angled stroke out from the mast, about ¾" (2 cm) above the hull, stopping above the right side of the boat.

10. For the sails, mix a very, very light wash of ultramarine. Paint a triangular sail shape on the left that extends from just below to the top of the mast, with the bottom corners touching the end of the left boom and hull.

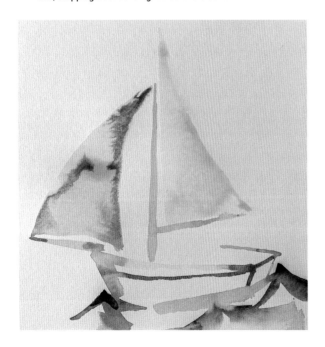

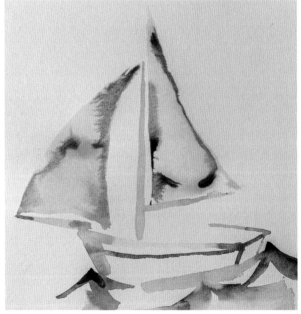

11. Paint the sail on the right side of the mast, starting at the top with a sweeping motion and extending it down until it reaches the right tip of the boom. Fill the rest of this triangle in using the light wash.

12. Using medium ultramarine wash and just the very tip of your brush, add a stroke at the edge of the right side of each sail. These areas should still be very wet, and the extra stroke will diffuse out.

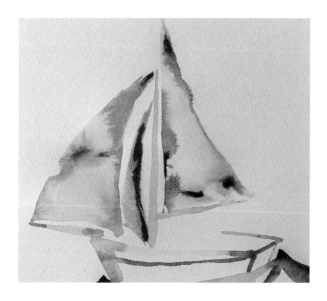

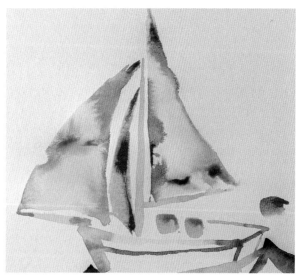

13. Wash your brush and load it with red to create another triangular sail that lies to the left of the mast and sits behind the far left sail. You will only paint in two-thirds of this red sail. Let the whole piece dry.

14. Add a patch of red just above the stern of the boat—this will be a flag. Use brown wash to paint two rectangular areas that will become cabins.

15. Ink can be used quite sparingly in this piece. Look for areas where the wash is very faint and the ink could support that edge. Consider adding ink to some of the edges of the sails, and outline the cabins, flag, and upper edge of the hull.

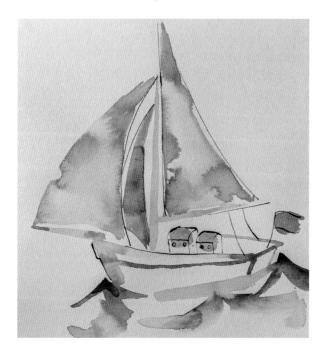

One of the greatest challenges for an artist is knowing when to stop. Unfortunately, watercolor paintings are easy to overwork, and knowing when to stop is especially important. As a general rule, "If in doubt, leave it out." Remember, every detail doesn't need to be included for our minds to figure out what the scene or object is.

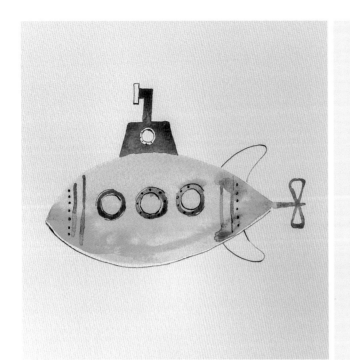

SUPPLIES

>> Cobalt turquoise *(or a mixture of blue with a tiny drop of yellow)*, light, medium, and concentrated washes
>> Ultramarine or cerulean blue, medium wash
>> Round #12 or #14 brush or quill #2 or #4
>> 140lb (300 gsm) paper
>> Pen and ink

Submarine

I can imagine having a little underwater adventure in this sweet submarine. The main body of the submarine is basically a double-pointed oval or an eye shape. In this version, the right point is slightly more elongated, as it eventually becomes the propeller shaft.

1. Load your brush with light turquoise wash and, using heavy pressure, paint the top edge of the "eye." Then paint the bottom edge to complete your shape. On the right side, extend the point so it's just a little bit longer and tapered.

2. Fill in the rest of the submarine using the wash. Let it soak in for one to two minutes, then load your brush with the medium turquoise wash and paint a long stroke following the underside of the sub.

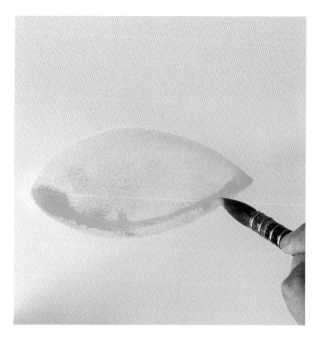

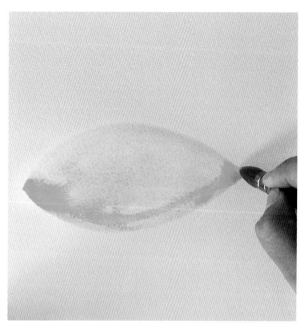

3. Load your brush with the concentrated turquoise. Using medium pressure, paint a stroke along the bottom of the submarine following the contour of the eye shape.

4. Add extra dabs of concentrated turquoise at the nose and tail of the submarine. Let all the washes soak in for four to five minutes.

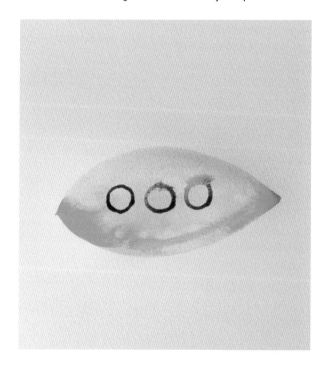

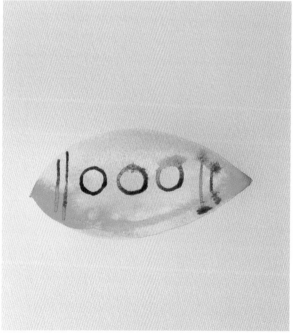

5. Load your brush with ultramarine to paint the porthole windows. Start with the middle window, using light pressure to make a thin stroke to paint the circle. Follow with a circle on either side with a small gap in between.

6. Near the nose of the sub, paint two thin vertical, parallel lines, again in ultramarine wash. Repeat this toward the tail of the sub.

(continued)

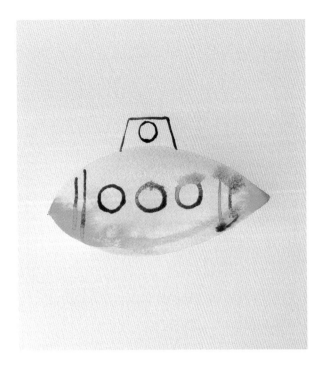

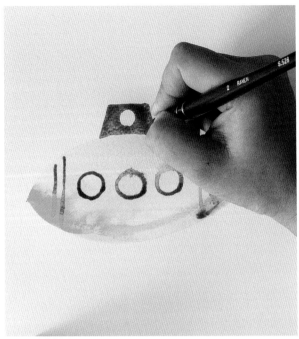

7. The conning tower is where the periscope peeps up. This area sits on top of the submarine, directly above the middle window. Using gentle pressure and ultramarine wash, draw a trapezium shape with a small, round window in the middle.

8. Fill in this shape but leave an unpainted circle in the middle for the window.

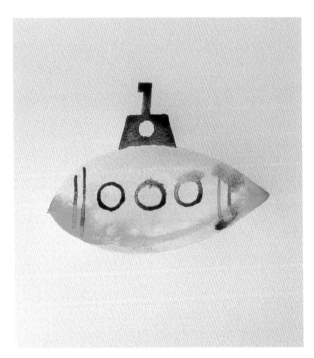

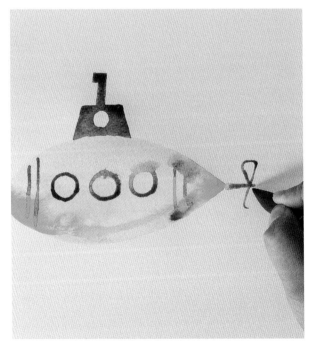

9. On top of this, add an inverted L shape in ultramarine to make the periscope.

10. To make the propeller, extend a thin line from the back of the submarine and draw on two small fins. Let this dry completely.

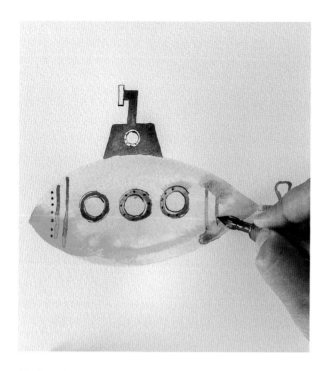 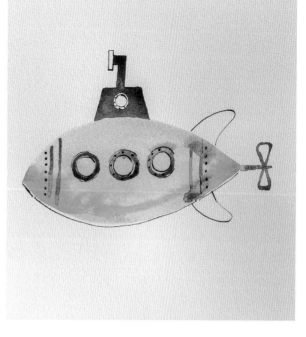

11. Use ink to draw in the rivets along the short parallel lines and the inside of the windows, plus a small rectangle shape at the end of the periscope.

12. You can now add the large fins toward the tail of the submarine using ink. Then, finish with a line that runs along the bottom of the submarine.

Don't let mistakes get you down when using watercolors. If you mess up your painting, see it as an opportunity to learn from the mishap. The reality is, the more mistakes you make, the better you'll get. It'll be frustrating at times, but it takes a while to understand the nuances of this medium.

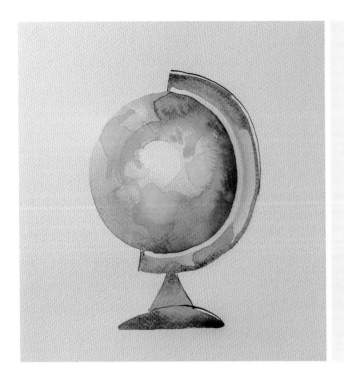

SUPPLIES

- >> Blue *(cobalt or ultramarine)*, medium and concentrated washes
- >> Yellow ochre or raw sienna, medium wash
- >> Burnt sienna or burnt umber, medium wash
- >> Green *(sap green or May green)*, medium wash
- >> #14 round brush or #4 quill brush
- >> 140lb (300 gsm) paper
- >> Pen and ink

Globe

Decorative globes are beautiful as well as useful. Although they are no longer used for navigation by sailors, they still give us a chance to explore from our armchairs.

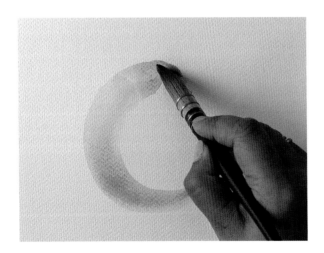

1. Using heavy pressure and a fully loaded brush, make a thick circle using the medium blue wash, leaving a circular gap in the middle where the paper shows through.

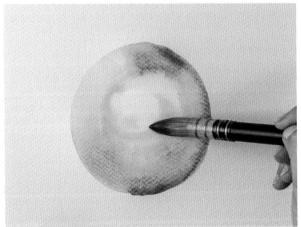

2. Wash your brush so there is only water on it, then, using the pigment that is already on the paper, use the clean brush to diffuse the inner edges of the blue circle to soften them. There should still be a small amount of unpainted paper showing through.

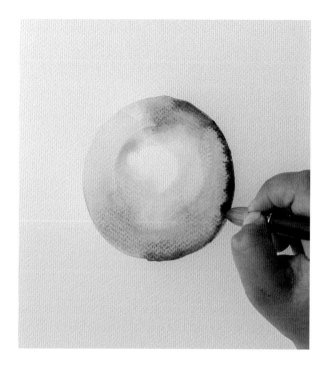

3. Now pick up the concentrated blue wash and use it to add an outline on the right side of the circle.

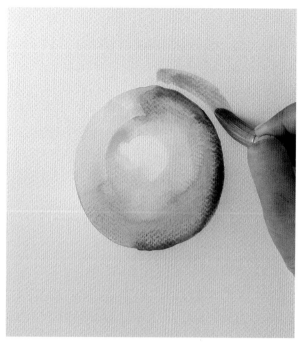

4. Wash your brush well, then fully load it with ochre to paint the wooden bracket. Starting at the 1 o'clock position, use medium pressure with your brush as you follow the contour of the blue circle to the 7 o'clock position.

5. Square off the ends and thicken this wooden section so it's about 0.6" (1.5 cm) thick.

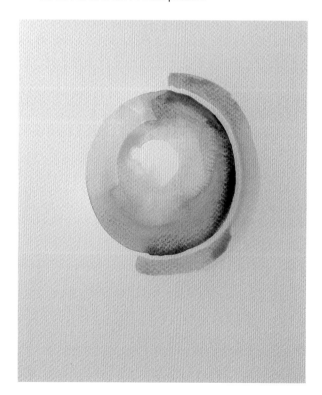

(continued)

6. Load your brush with more ochre paint to paint a triangle attached to the wooden bracket. The tip should be at the 6 o'clock position.

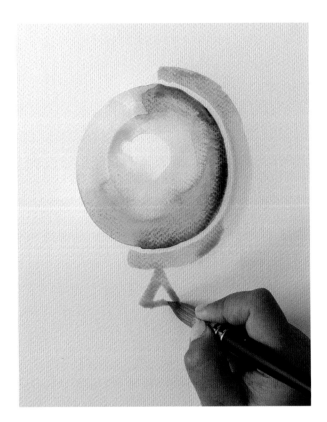

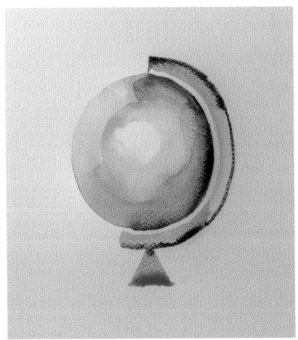

7. Using brown paint with light pressure, add a line to the right side of the bracket.

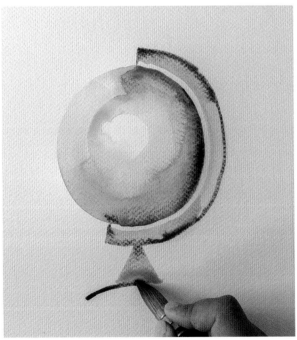

8. Next, add the poles that hold the globe in place at the top and bottom. Use brown paint and short strokes to attach the globe to the wooden bracket. Add the base of the wooden stand with brown paint. It's a shallow semicircle shape.

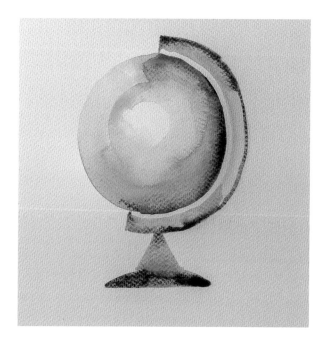

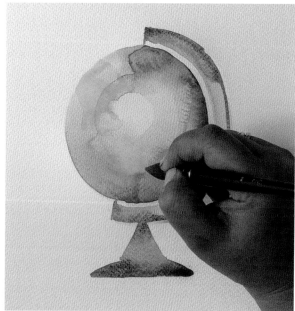

9. Fill in the base of the stand with brown paint, letting the paint merge with the ochre above. Let the whole piece dry completely at this stage.

10. Using the green wash and the tip of your brush, start painting in the outlines of the continents, then fill them in. You won't be able to fit everything in, so it's your choice what to include. Let this dry completely.

11. Use ink lines to add the outer edges of the bracket, triangle, and base.

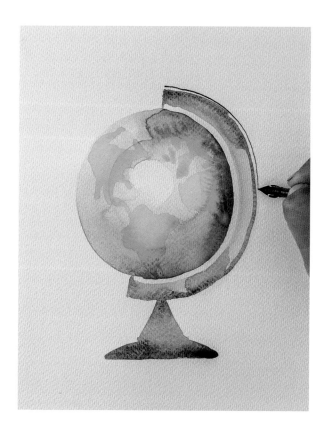

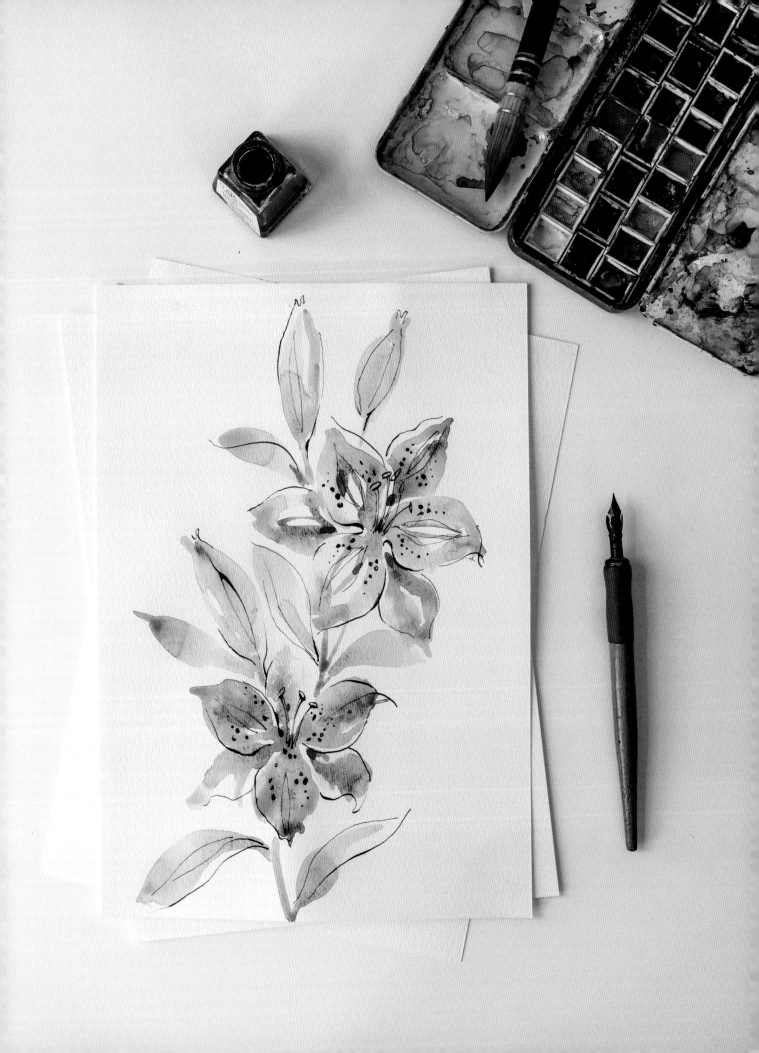

7

Florals

I have a whole watercolor sketchbook dedicated to wildflowers I saw during daily walks in my neighborhood. There's a seasonality to them, which I love to see when flicking through those sketches. It also helped me refine my process and gain a better understanding of their structure and huge variety of forms. And it really expanded my use of color mixtures, by letting the many pigments mix on the page. I even changed over to quill brushes during this period in order to load my brush with more wash.

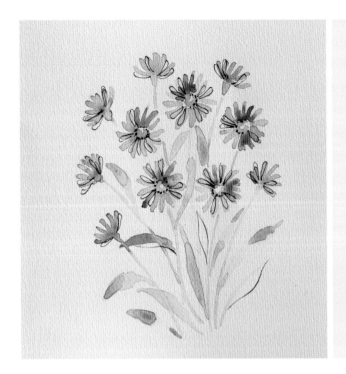

>> Purple, violet, or mauve, light and concentrated washes

>> Pink, rose, or carmine, medium wash

>> Green, olive, Hooker's green, or sap green, medium wash

>> Cadmium yellow, lemon, or Turner's yellow, medium wash

>> Round #12 or #14 brush or quill #2 or #4

>> 140lb (300 gsm) paper

>> Pen and ink

Douglas Aster

Asters are daisy-like flowers that symbolize love, wisdom, and faith. Although they come in a variety of shades, including white and pink, for this project I've chosen lilac. They make a very pretty informal arrangement that will brighten up your day.

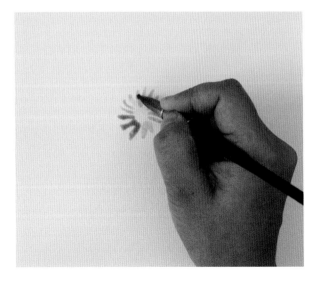

1. Load your brush with light purple wash, then use the tip of your brush with gentle pressure to create a lot of small strokes radiating outward from a central point. Pretend there's a small circle in the middle and these petals are attached to it. These strokes don't have to be evenly spaced.

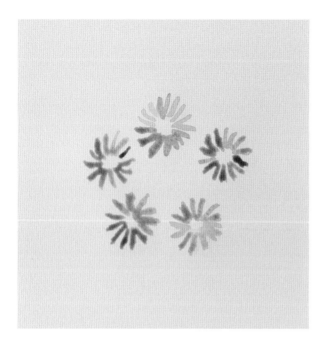

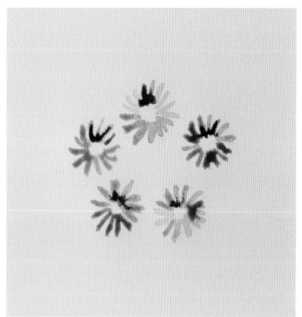

2. This first aster will be at the top of a pentagon formation. Paint the next four asters using the same small strokes on a different point of the pentagon arrangement.

3. Load your brush with the concentrated purple wash and place a drop in each of the sets of petals; it doesn't matter too much where. Wash your brush and load with the pink wash and drop into a different part of each set of petals.

4. Wash your brush and load with green wash. Paint a very thin stroke using the tip of your brush in a downward motion, from just underneath the two lowest-placed asters. Add another thin stem underneath the other aster the same length as the first.

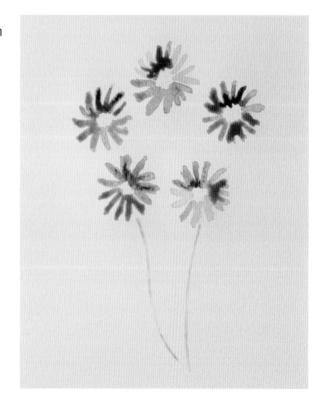

(continued)

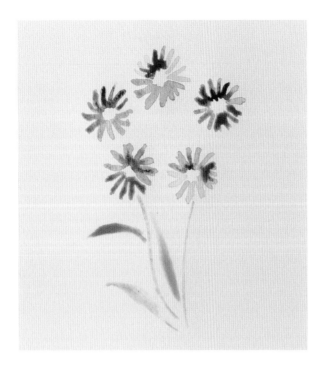

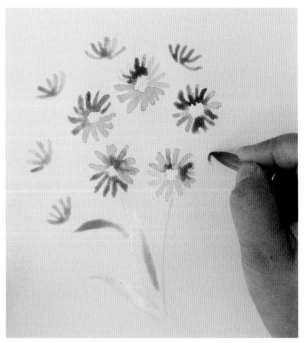

5. Load your brush with more green wash to add the leaves. Start by using light pressure to place the tip, then slowly press down and move it in a diagonal motion, then lift (similar to the warm-up on page 48).

6. We need to fill in the rest of this arrangement by adding more asters, this time in profile, from a side view. From a central point, fan out the petals using the same type of small, quick brushstrokes as before. About six to eight of these placed around the hexagon will look great.

7. Wash your brush and load with green wash to fill the remaining spaces between the flowers with small leaves and stems. Overlap some of the leaves and stems toward the bottom, underneath the bulk of the asters.

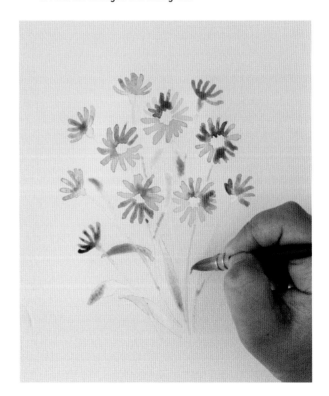

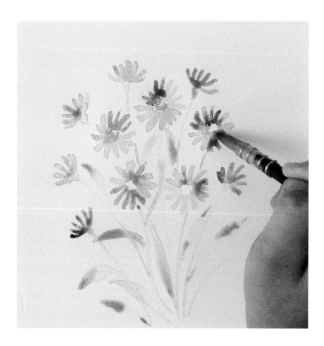
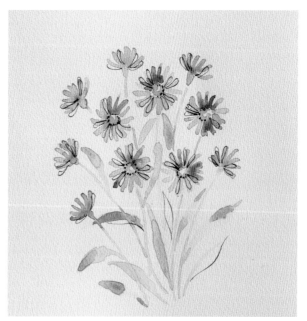

8. Wash your brush and load with yellow wash to paint the middle of each aster, leaving a tiny patch of white for contrast. Allow to dry fully.

9. Consider inking the outlines of a few petals. Also try adding a few dots along the outside edge of the yellow centers to suggest a slightly bumpy texture. Some of the petals and leaves may need a tiny bit of ink definition too.

When I go out for walks and find lovely flowers in the hedgerow, I often take a quick photo. I have several folders on my phone where I keep these images for quick reference to inspire color combinations, leaf forms, or anything seasonal that might spark my imagination later.

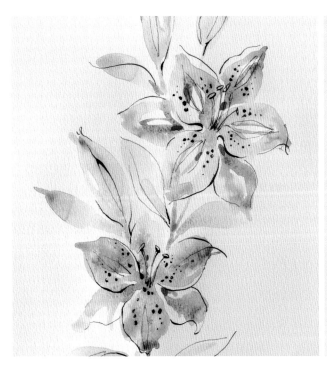

SUPPLIES

>> Pink *(potter's pink, permanent rose, or any pink)*, very light and concentrated washes
>> Red *(primary red, carmine, or magenta)*, medium wash
>> Green *(sap green or olive green)*, medium and concentrated washes
>> Yellow, medium wash
>> Round #12 or #14 brush or quill #2 or #4
>> 140lb (300 gsm) paper
>> Pen and ink

Stargazer Lily

I adore stargazer lilies, due to the rich pink interiors of the petals. They symbolize prosperity and abundance. I often paint these from life, as it provides the opportunity to see the flower's structure and nuances of color.

These petal shapes and formation can be tricky to paint at first. If in doubt, practice steps 1 and 2 on printer paper to build up your muscle memory before beginning on watercolor paper.

1. Load your brush with very pale pink wash to create the first of the petals. As some of the petals are white in places, we won't need to fill them all in with color. Aim for a teardrop shape at a slight angle, with a tapered point at the other end. Paint two more petal shapes at equal 120° angles to each other, making sure the tapered points join in the middle.

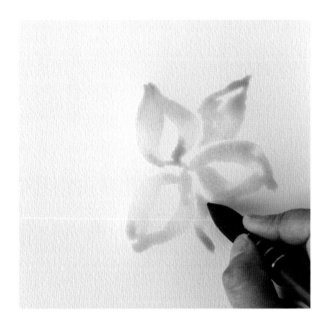

2. While the pigment and wash are soaking in, paint in the petals in the adjacent spaces between the first set of petals so they appear to be behind them. Start painting using the light pink wash, leaving a tiny gap between the two sets of petals.

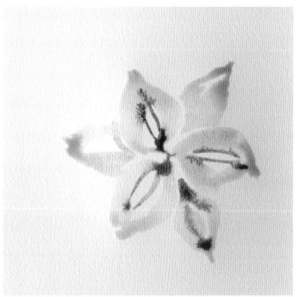

3. To create the markings, pick up a concentrated red wash and quickly paint in a thin line using the tip of your brush, using gentle pressure down the middle of each petal; watch it diffuse outward.

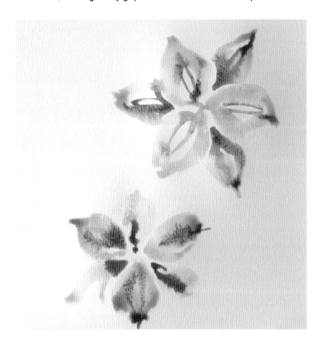

4. Repeat steps 1 to 3 to paint another lily to the left and below your first one.

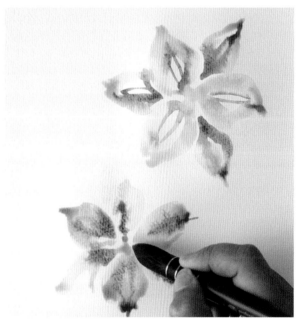

5. Wash your brush thoroughly and replace your water. Load your brush with a medium-value green wash and dab a few times in the very middle of the flower, then watch it diffuse with the pink. This will form the backdrop for inked stamens later on.

(continued)

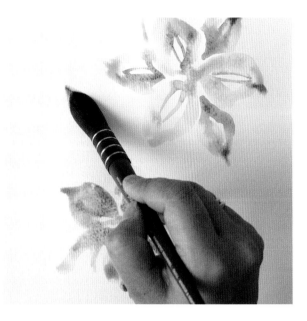

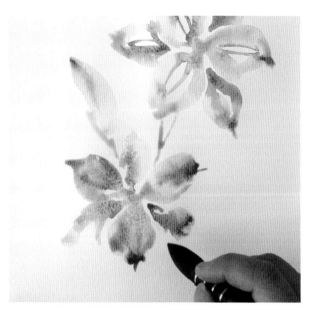

6. To paint the lily bud, paint a fairly long green stroke at a slight angle a little above the top flower, using medium pressure. You may wish to add one or two additional buds in the same way.

7. Wash your brush again and load with a medium pink wash. Above the flower on the left create a similar long stroke. Using the tip of your brush, make a stroke down one side of the bud while it's still damp so the two pigments can mingle slightly.

Negative space is the space around or between objects in an image. The positive space is the subject or object of the image. I like to fill negative spaces so the eye isn't drawn to the large gaps. Overall, the composition will feel more balanced.

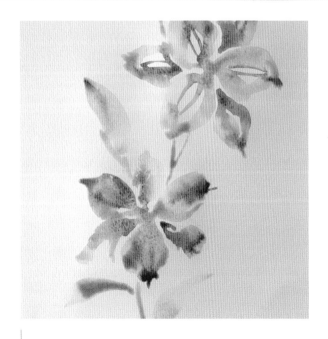

8. Imagine all these buds and your main flowers are all connected by a central stem. Starting with the uppermost bud, add a short stem using the medium green wash. Think about what angle the other buds might attach to a thicker green stem that will emerge underneath the lower flower.

9. We need to add leaves in some of the negative spaces, where there is room. Load your brush with the green wash and, starting from the stem, sweep your brush outward in a slightly curved motion, using heavy pressure. They don't have to be fully formed leaf shapes, as we will add ink details. Add a few small drops of concentrated green where they attach to the stem, and also dab some yellow wash in the middle of each leaf.

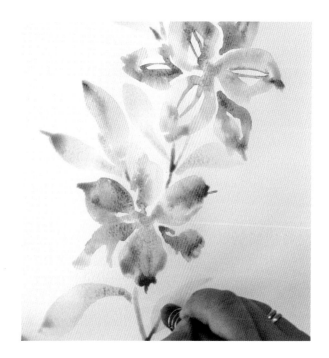

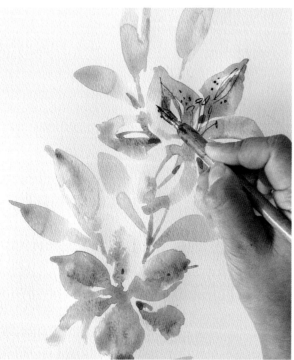

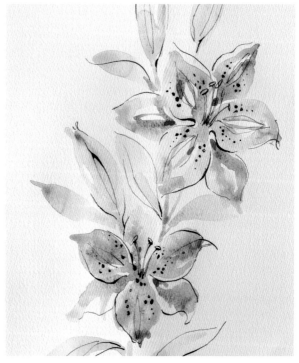

10. After all the watercolor has dried, start inking in a few of the stamens, the delicate curved stalks, or filaments, with the oval packages of pollen at the ends. They're quite long and come outward from the middle of the flower. Three to five should give the impression of a central grouping.

11. Decide which of the petals may need some inky lines to distinguish them, but don't outline all of them. And a line down the side of each bud. Finish by adding a few distinctive inky dots down the middle of some of the petals.

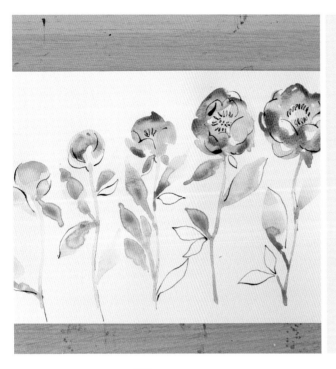

SUPPLIES

>> Coral mixture of pink and orange *(carmine and cadmium orange)*, light and concentrated washes

>> Cadmium yellow, medium wash

>> Green, sap green, or olive green with cadmium yellow, medium wash

>> Round #12 or #14 brush or quill #2 or #4

>> 140lb (300 gsm) paper

>> Pen and ink

Coral Peonies

This lovely group of peonies shows the different stages of blooming from bud. The five versions make for a lovely display across the page.

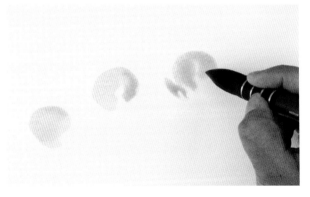

1. Start with the smallest bud on the far left. Use light coral wash with medium pressure to almost make a full circle shape. Load your brush with coral again and move along and up diagonally, leaving enough space for the leaves, which will come later. Paint a larger full circle shape using medium pressure with your brush, leaving a small gap at the bottom.

2. Load your brush with coral and place it to the right of the last bloom. Paint a slightly larger circle shape to the right. This time, add some small strokes to make the edges rough.

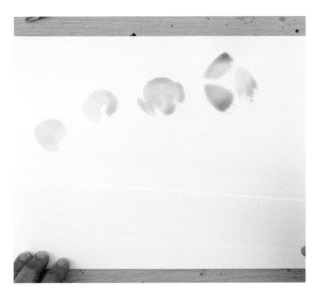

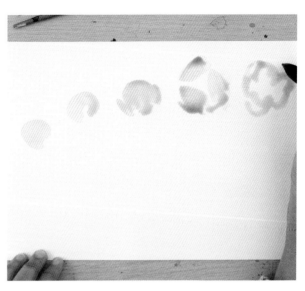

3. The fourth flower is almost in bloom, so load your brush with more coral wash and move along and up again. Using heavy pressure, paint a stroke at 120°, repeat with another stroke at 240°, and the third heavy-pressure stroke at 360°. Using the tip of the brush, use the pigment that's on the paper to create two shallow semicircles just underneath, which will eventually form outer petals.

4. The final peony is in full bloom, so it needs the most space and a light touch. This involves creating more shallow semicircle strokes going around in a circular formation, using medium pressure.

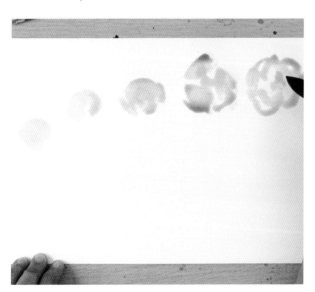

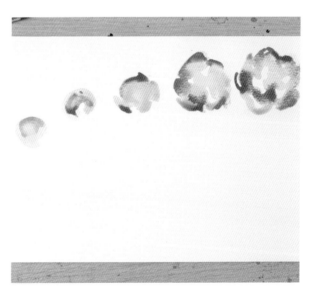

5. Wash your brush and load with yellow wash. Add a drop to the middle of the third, fourth, and fifth peonies.

6. Wash your brush again and load with the concentrated coral. Add a drop to the top part of the first two flowers. Then add a drop toward the middle of the third, fourth, and fifth flowers, and watch the pigments diffuse. Wash your brush.

(continued)

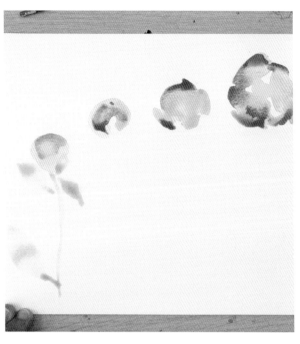

7. Load your brush with light green wash. On flower 1, place a green stroke just to the side and underneath the bud. Then paint a thin downward stroke that isn't quite straight and almost reaches the bottom of the page. Add a few leaves by pressing down firmly next to the stalk and lifting upward. Place a second smaller leaf next to it.

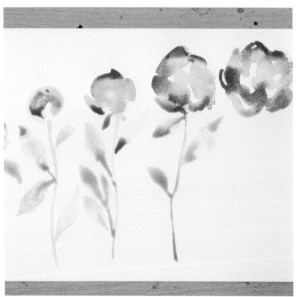

8. Repeat this process for the rest of the peonies, placing the leaves at different parts of the stem from flower to flower. Wash your brush and load with yellow wash, then add a few drops on the tips of some of the leaves to create some contrast. Let this dry completely.

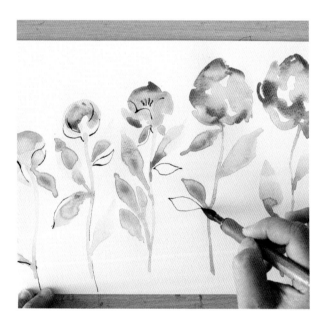

9. Start the inking by adding a few lines to the leaves if they need some definition. If there are spaces, consider adding a few inky leaf outlines to fill the gaps.

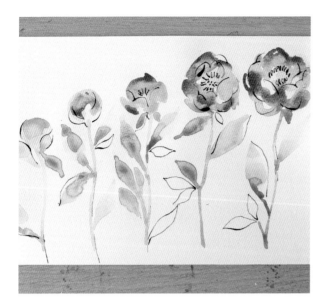

10. Next we need to pick out a few petal details, mainly edges. Keep it to a minimum on peonies 1 and 2. On flowers 3 and 4 we can define the edge of unfurling petals with scallop-like strokes. You will need to add more scallop ink lines toward the outside edges of flower 5. Add the tiny yellow stalk details in the middle of each flower.

Leaving unpainted areas of the paper for luminous white shapes is an important part of working with watercolor. It might be difficult, but restraint is required when painting light and shade in pale flowerheads because you have to leave much of the white paper unpainted. But I feel that you achieve fresher, purer, more natural results that will contrast better with the rest of the piece.

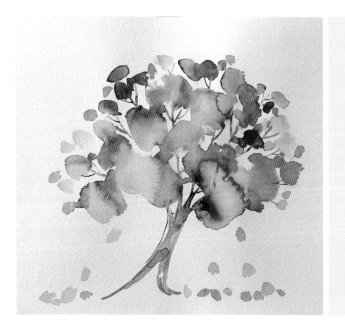

SUPPLIES

- >> Pink *(rose madder)*, very light, medium and concentrated washes
- >> Brown *(burnt sienna or raw umber)*, medium wash
- >> Round #12 or #14 brush or quill #2 or #4
- >> 140lb (300 gsm) paper
- >> Pen and ink

Cherry Blossom Tree

I love late spring, when the cherry trees in my neighborhood are in full bloom—it's something I look forward to every year. This project is, in part, a playful adaptation of the variegated wash technique with pink and red diffusing gently with the brown of the trunk. You will have to work fast and judge the dampness of the paper. Revisit the drying-time section on page 32 if you need a refresher.

1. The basic shape of the blossoming part of the tree is an extended semicircle. Start at the top and work outward. With light to medium pressure, use the light pink wash to dab fairly random and irregular patches of wash along the left edge of an imaginary semicircle. Use the side of the brush to create some of these marks.

2. Repeat the same type of brush marks along the right edge in pink wash.

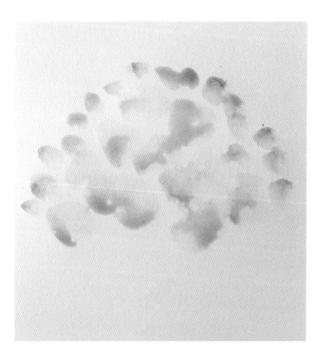

3. Fully load your brush with medium pink wash to start filling in the middle of the semicircle. Increase the pressure on your brush so the dabs are much larger as you move down to indicate mass clumps of blossoms on branches. Leave some paper showing through in between the dabs.

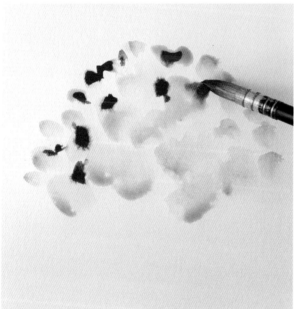

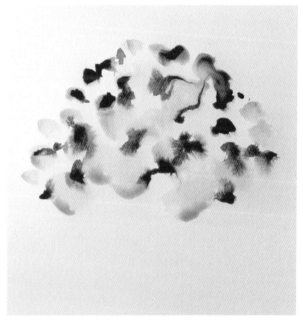

4. Leave this all to soak in for two to three minutes so there's not too much standing water on the surface. Then load your brush with medium pink wash and add drops randomly into the first layer of wash, starting with the outside edges of the blossom canopy.

5. Add more concentrated pink to the middle of the tree canopy.

(continued)

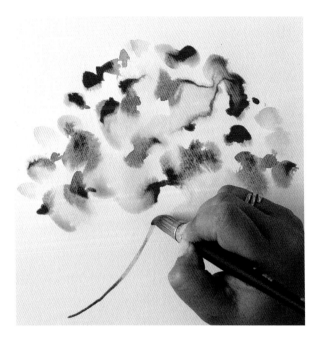

6. Wash your brush and load with brown wash to start on the tree trunk. Using medium pressure, start with a sweeping curve underneath the left edge of the blossom canopy so it looks like the trunk is slightly leaning.

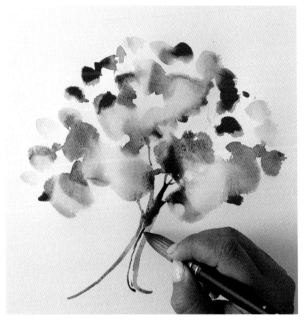

7. Fill in the rest of the trunk with three main branches spreading outward and upward.

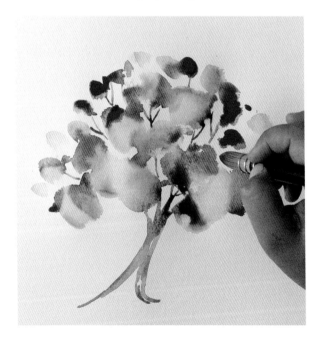

8. Try to imagine how these branches would travel up behind the clumps of blossoms and split into smaller branches. Use gaps in the pink wash to add very thin branches, using lighter pressure.

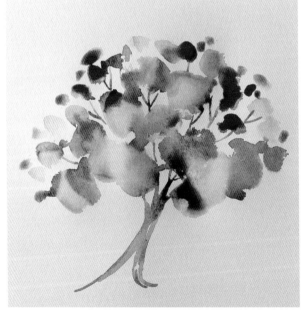

9. The brown branches may start blending with the pink, but this will add to the overall look. Include a few thin branches poking through the canopy, and also add small clumps of blossoms at the ends to give the tree a nice shape.

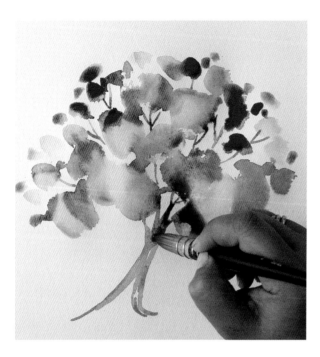

10. Wash your brush and load with medium pink wash. Add a drop of pink to the trunk to harmonize all the colors.

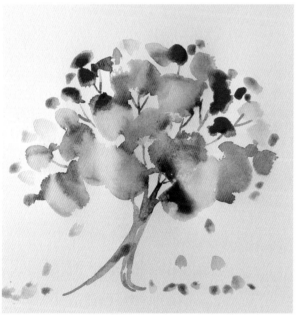

11. Add a scattering of blossom petals on either side of the tree trunk, as if they have fallen to the ground. Add some falling off the tree.

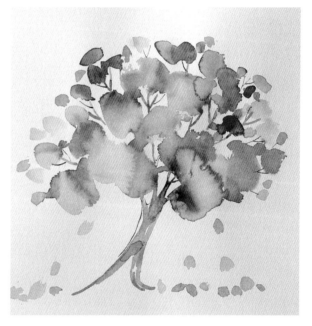

12. Use ink mainly in the trunk and to pick out some of the very fine branches poking out at the top of the canopy.

Acknowledgments

I feel very grateful to be able to share my love of watercolors and explorations with this medium in this book. Although we lived a humble life as a child, there were always pens and paper to let my imagination run free in the evenings. I give thanks to my parents and sister who were always wonderfully supportive of my need to push my creative pursuits to its full potential. And along the way there have been many mentors who have encouraged me to stay curious and not to give up on my artistic dreams. Thank you to my very special friends who have provided endless support and valuable advice over the years. Also to my ever-enthusiastic students who have embraced everything I've shared and are just as keen on their watercolor practice, whether at workshops or in classes.

Finally, a thank you to the team at Quarto for approaching me to share my excitement and guiding me through this latest adventure. Also a special mention to Nat, my photographer who sustained my vision for this book.

About the Author

Ohn Mar is an illustrator, designer, and teacher based in England. She is an advocate of sketchbooks, with more than 25 Moleskines serving as a record of her creative journey as a self-taught watercolorist for the last five years. Oftentimes, these sketch explorations provide the basis for her classes and workshops. She loves to teach—with over 20 watercolor and illustration classes with over 140,000 students on Skillshare. Students often remark how calm and engaging Ohn Mar is with her reassuring and considered approach.

Her mission statement is: "I use my creativity and intuition to support and inspire myself, and then help others do the same," which allows Ohn Mar to remain open to new opportunities, learn, inspire, and keep creating.

She is also known for her fruit and vegetable illustrations, which have appeared on countless branding and packaging projects all over the world.

Website: ohnmarwin.com

Instagram @ohn_mar_win

Index

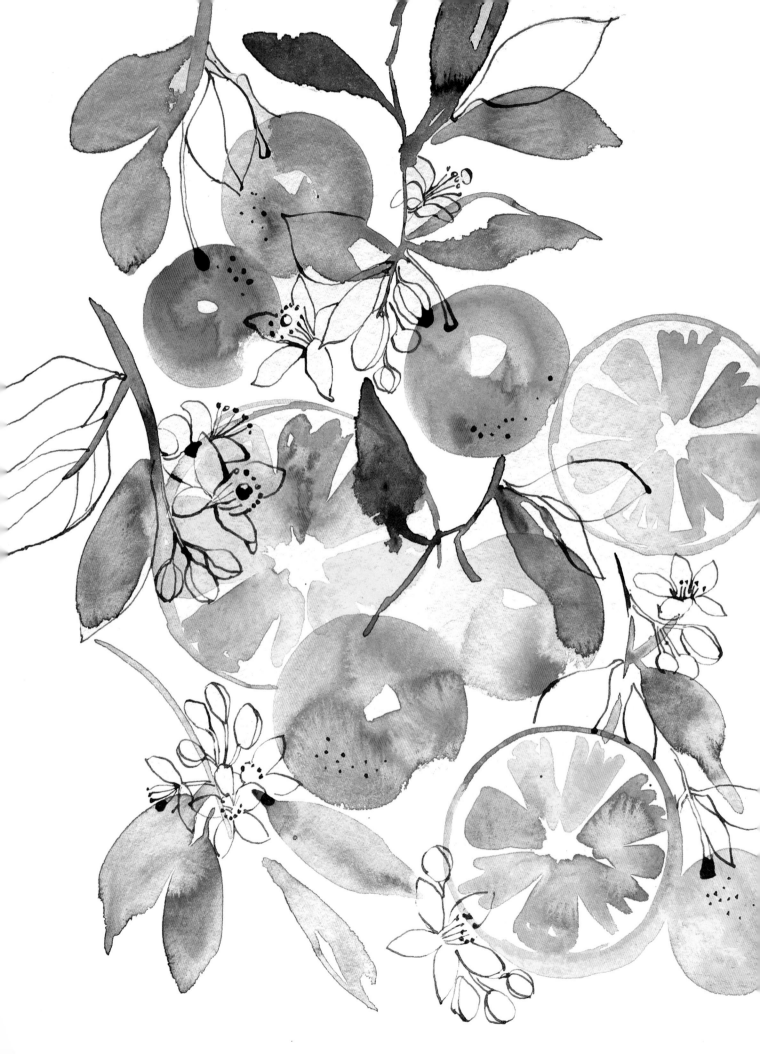